IMAGES
of America

FLORHAM PARK

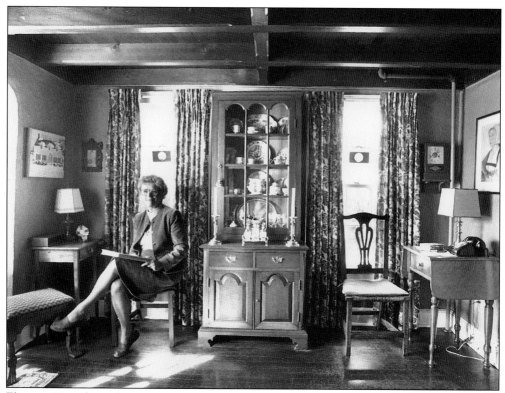

Eleanor Weis, shown here in 1989 on the occasion of publication of her acclaimed book, *Saga of a Crossroads: Florham Park,* has lived in the borough for more than 57 years. She has witnessed Florham Park's transformation from farmlands to a bustling suburban community replete with home developments, industrial parks, and prominent institutions of higher education. As a one-time newspaper editor, correspondent, and columnist, she has rare awareness of borough history. This book depends in very large measure on her advice, knowledge, and generous assistance. She is, best of all, a close and dependable friend. For all of these reasons I dedicate this book to her.

John T. Cunningham

On the Cover: This log cabin was built on the Braidburn Country Club property in the 1920s. The photo is dated May 6, 1927.

IMAGES
of America

FLORHAM PARK

John T. Cunningham

ARCADIA
PUBLISHING

Published by Arcadia Publishing
Charleston, South Carolina

Printed in the United States of America

Library of Congress Catalog Card Number: Applied For

For all general information contact Arcadia Publishing at:
Telephone 843-853-2070
Fax 843-853-0044
E-mail sales@arcadiapublishing.com
For customer service and orders:
Toll-Free 1-888-313-2665

Visit us on the Internet at www.arcadiapublishing.com

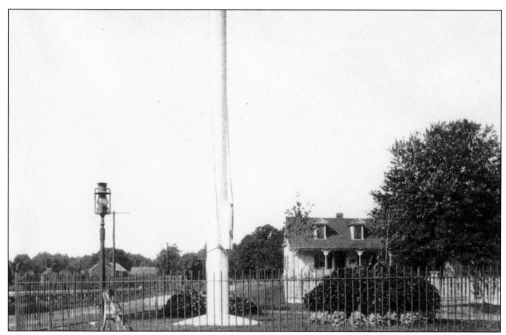

This was the center of Florham Park in 1903, four years after the borough was established. The town centered on the towering flagpole, said to be almost 75 feet tall. To the left is one of the borough's distinctive kerosene street lamps, a sure way to identify early Florham Park photographs. To the right of the pole is the home of beloved teacher Geneva Pruden. The lamp, the pole, and the Pruden house all have disappeared into the mists of time.

Special acknowledgment is made to Andrew Bobeck for his painstaking and artistic generation of the scanner files for this book. Many of the very old pictures were nearly useless until he restored them to full quality.

CONTENTS

ACKNOWLEDGMENTS

This book is about nostalgia, which is why most of its photographs were taken before 1970. Those disappointed in not seeing modern pictures can start saving their best photographs: Volume II is a possibility.

My gratitude to the people of my hometown includes many organizations and individuals. Foremost is the Florham Park Historical Society, which opened its files for me and coordinated materials submitted by community people. Gladys Eddy, society president when this book began, was especially encouraging. Several society members helped find and sort photographs, including Dorothy Dorn, current society president; Christine Davidson; Betty Garcia; Eileen Hoffman; and Eleanor Weis.

Two descendants of the large and important early-20th-century Florham Park farming family named James, Christine Davidson and Laura Holly-Dierbach, supplied several remarkable turn-of-the-century photographs documenting both the James family life and farm life in general. The series of pictures of Stu Kurtz as a boy growing up in World War II were supplied by Wilma Kurtz. The pictures of Bogert and Eleanor Cox were loaned by Mrs. Cox.

I am indebted to many others: Stan Beck, Carmen Di Sarno, Mary Hupcy, Gene Jewell, Arthur Kinsman, Carol Manker Kinsman, Kenneth Kopia, Dave Kramer, Doug Kramer, Barbara McConville, Marilyn VanVoorhis Nash, Elda Felch Ochs, Andy Picone, Don Tietjen, former Police Chief Richard Ruzicka, Police Chief Jack Treiber, and Malcolm Welsh.

Picture aid came from Fairleigh Dickinson University, and from Sr. Elizabeth McLoughlin and Sr. Mary Ellen Gleason, archivists at the College of St. Elizabeth. Holy Family Church provided needed photographs.

Borough agencies that helped were the Florham Park Volunteer Fire Department, the Memorial First Aid Rescue Squad, and the Florham Park Police Department. Assisting libraries included the Florham Park Library, the Madison Public Library, and the Joint Free Public Library of Morristown and Morris Township.

My longtime friend and colleague Howard Wiseman, a noted connoisseur of photographs, aided in location of several important illustrations. I have reserved special mention of Andrew Bobeck for page 4.

John T. Cunningham, Florham Park, 1999

INTRODUCTION

"Little Red," more properly known as the Little Red Schoolhouse, stands serenely on the northwest corner of Columbia Road and Ridgedale Avenue in the center of Florham Park. It has survived more than 130 years of time, highway widenings, and the era of the bulldozer in the 1950s and 1960s, which doomed many of Florham Park's historic buildings near the old town center. Three shopping centers replaced them.

If it were not for Little Red, the Florham Park Roller-Sating Rink, and the Afton Restaurant, the center of Florham Park might be recognized as little more than a widened spot on Columbia Turnpike. Both the rink and the restaurant have served town visitors for more than 65 years. They also have historical status.

The first settler arrived here nearly 300 years ago. It is arguable whether the first was a Campfield (Canfield) or a Hopping, but it is indisputable that John Hopping knew how to dominate village history: his nine children included eight sons. The crossroads town was called Hoppingtown before the American Revolution.

Hoppingtown became Columbia in 1802 in a burst of patriotic spirit, and when the Newark-to-Morristown turnpike opened through town in 1817, the new roadway was called Columbia Turnpike. The village unofficially became Broomtown to honor several local broom factories. Finally, in 1877, it was named Afton, suggested by an anonymous poetic soul who somehow confused the local, muddy, meandering Passaic River with the stream in the lovely old British song "Flow Gently Sweet Afton." By any name the village was merely a hamlet in very large Chatham Township, which also included today's Chatham and Madison Boroughs.

In 1898, multi-millionaires Florence and Hamilton McKeon Twombly, owners of more than 1,000 acres in the area, pressed for separation from Chatham Township, in awareness that it would lower their annual local taxes. Dr. Leslie D. Ward, a leading officer in the giant Prudential Insurance Company and owner of a vast estate called Brooklake Park, joined the antitax Twomblys.

What were the Afton burghers to do? They accepted the secession on March 20, 1899. The Twomblys renamed the village Florham Park, Flor-Ham from the first syllables of their first names. "Park" was a nod to Ward's estate. According to town historian Eleanor Weis, Florham Park was dubbed "the wealthiest town with the lowest tax rates in America."

What is now Park Avenue was in 1899 Convent Avenue, to underscore the huge land holdings of the Sisters of Charity on both sides of the street. In the year of renaming the village of Afton, the sisters opened the College of Saint Elizabeth, the first New Jersey college to grant four-year degrees to women.

Almost overlooked in the Twombly-Ward shows of wealth was the borough's all-time, "local boy" success, Lloyd W. Smith. Smith was born in town in 1870 and attended the local one-room schoolhouse before his parents lost the family estate. He worked his way through Yale and Harvard, became a New York lawyer and investment banker, repurchased the family home, and became an unostentatious millionaire.

Smith's Harvale (for Harvard and Yale) Farm included huge apple and peach orchards, broad vegetable fields, and berry patches. Most of the post-World War II homes in the Afton Village section occupy the Smith orchards and fields. Smith's quiet generosity to many town groups included land for the Presbyterian and Catholic churches.

The widespread little borough had a population of some 1,600 persons in 1940. Graduates of the town's eight-grade school went to Madison High School, and citizens looked to Madison for emergency rescue aid, good stores, the library, and the YMCA. The Madison Post Office delivered mail on an RFD route. Several large rose growers, largely on the southern edge of town, buttressed the largely rural economy.

Since World War II, Florham Park has risen on former farmlands to be a prototypical suburban New Jersey town. Time, energy, and money have changed the rapidly built, once-treeless developments of the 1950s and 1960s into pleasant, shaded streets with most of the amenities of the urban areas that new residents fled to try "country life."

Yet a spirit of old Florham Park remains. It is a place where volunteers answer fire department and rescue squad calls, coach the youth teams, lead the Boy Scouts and Girl Scouts, and plan and sponsor Sunday night outdoor musical programs in front of the gazebo—built by volunteers. The Players Club has a 50-year history of fine performances. Most notably, volunteers have for nearly a half century mounted a huge, highly praised annual Fourth of July parade.

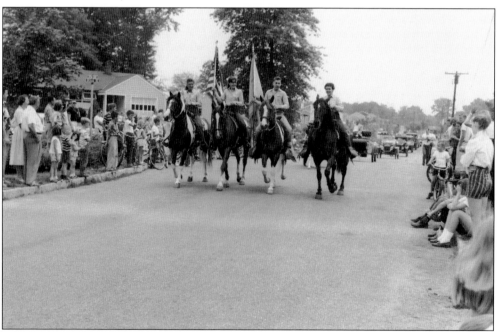

The days of horses—and horseless carriages—were emphasized in one of the early Florham Park Fourth of July parades. Out in front on horseback is the Cox family. Trailing behind are the vintage automobiles, which are an annual feature.

One

BEFORE THE MILLIONAIRES

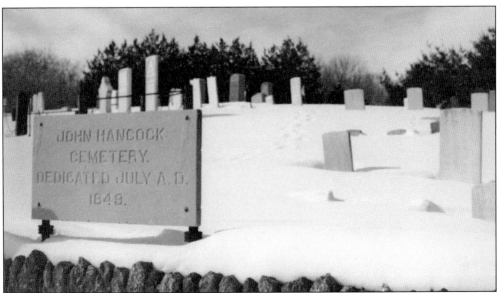

Millionaire estates rose on both the western and eastern edges of the village called Afton in the township of Chatham as the 1890s wore on, but the rest of the scantily populated settlement had been little changed as the 19th century neared an end. Hancock's Cemetery was established for family members in 1848 by Rev. John Hancock, a self-educated and versatile Methodist preacher. The cemetery was designated as a "public burial place" in Hancock's will.

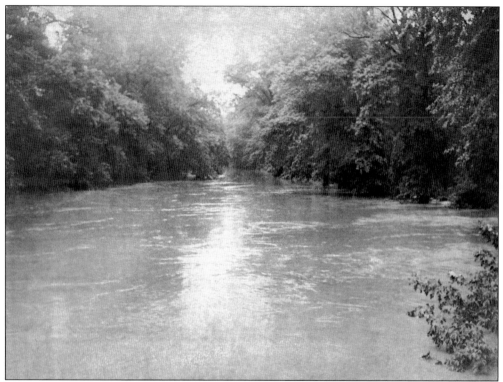

The slow-moving Passaic River, Afton's eastern edge, was not the gently flowing "Sweet Afton" of English antiquity, but it was impressive. It is still the eastern boundary and is still sluggish, although heavy rains spill river water over the banks into the marshes.

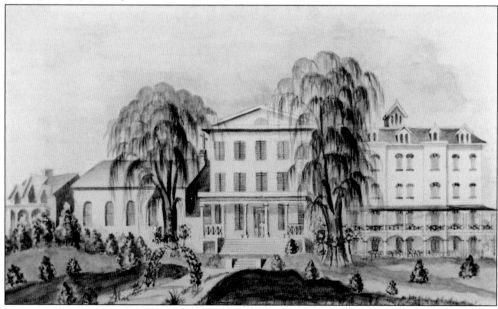

Afton's western edge was near St. Elizabeth's Academy, predecessor of the College of St. Elizabeth. Seton Hall University was founded in 1855 in the center building, a former stylish dancing academy for young women. Seton Hall moved to South Orange in 1860.

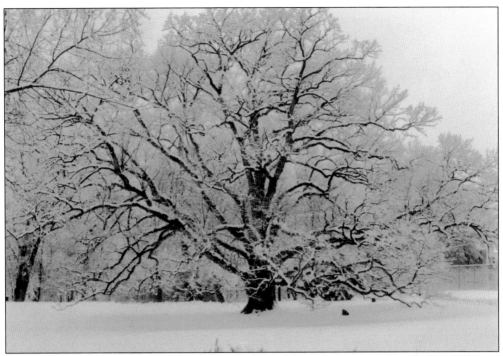

Near the southern end of the village, the Braidburn Oak by 1890 was already more than 250 years old. It still stands, a few hundred feet south of Brooklake (formerly Braidburn) Country Club. The tree is one of the oldest in New Jersey.

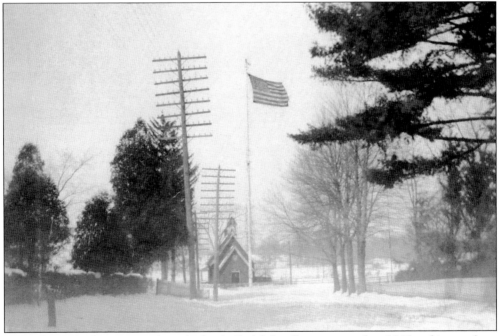

The village of Afton centered on the Little Red Schoolhouse opened in 1866 and is seen here during a snowstorm c. 1895. The huge flag flew from the towering flagpole even during bad weather. The flag and pole were both evidences of village pride.

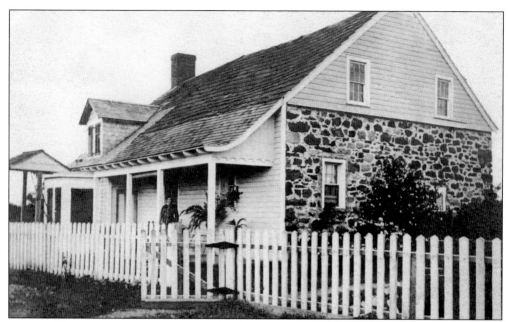

Several Afton houses predated the American Revolution, including the Stone House at 44 Elm Street. Owner John Young hosted an 1802 meeting that changed the name of the village from Hoppingtown to Columbia.

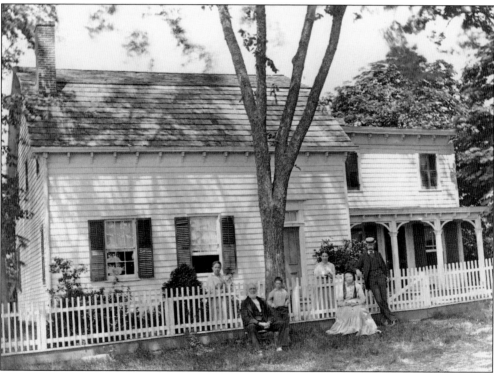

This house, c. 1750, was the birthplace of Leslie D. Ward, one of the founders of the large, powerful Prudential Insurance Company of Newark. By 1890, Ward also owned his huge Brooklake Park estate. The Ward house recently was razed to make room for two new buildings.

One of Florham's oldest houses is at 309 Brooklake Road. It is said that the oldest part was constructed *c.* 1730. It was built so close to the road that a corner of the structure now overlaps part of the sidewalk.

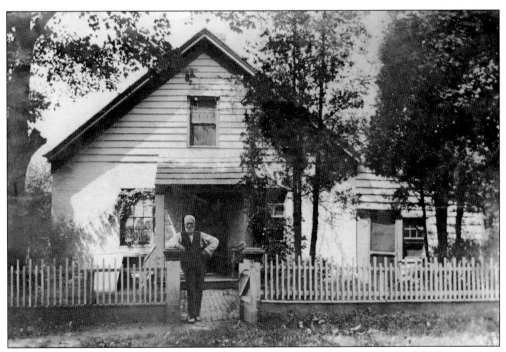

More representative of Afton homes was J.C. Goldberg's farmhouse on Ridgedale Avenue, just north of the village center. Goldberg's fence, like all other fences in town, was a place for greeting neighbors and exchanging gossip.

Afton's simple social life fitted the temperaments of the villagers. For those who were young, sitting on a fence near the town flagpole was joy fulfilled. An album caption called them "the lovers."

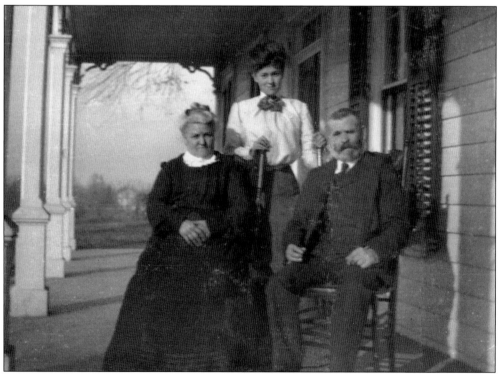

James Hopping, a member of one of the village's earliest families, sat for this family portrait with his wife and daughter. Originally the town was called Hoppingtown to honor the several branches of this old family.

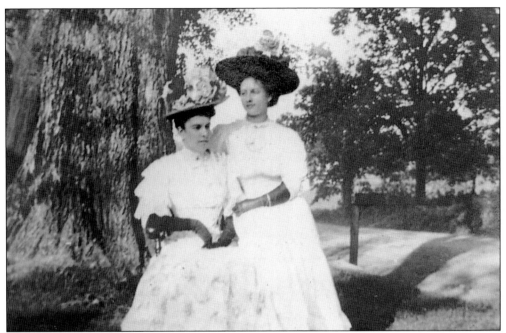

After enduring a long Sunday sermon on a hot midsummer day, Agnes James and close friend Rose Straussberger enjoyed sitting in the cooling shade of a sturdy old tree near the village center.

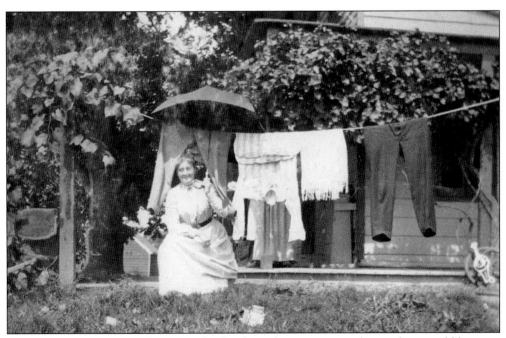

For someone who had just hung out the family wash on a summer day, nothing could be more rewarding than sitting on the back porch under a sun umbrella. The jovial lady is unidentified, but this photograph appeared in the Hopping family album.

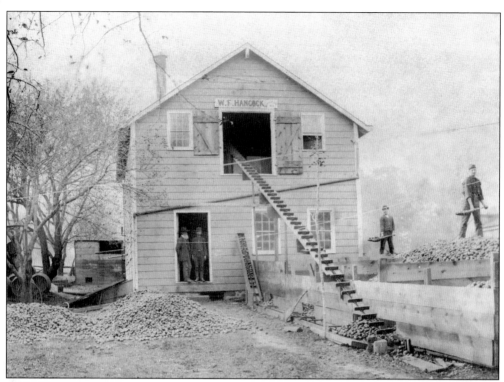

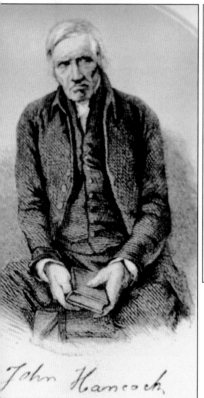

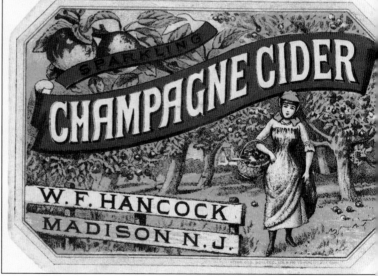

Rev. John Hancock, left, a multi-talented man, held the area's first Methodist service in his home near the cemetery. He also began a cider and vinegar business. After his death the family added alcoholic champagne cider to the cider and vinegar enterprise, above, but only until 1871. The Hancock cider enterprise operated for more than 150 years. The large, busy mill (top) is shown above on an autumn day in the 1890s. The mill closed in the 1970s after an apple shortage occurred.

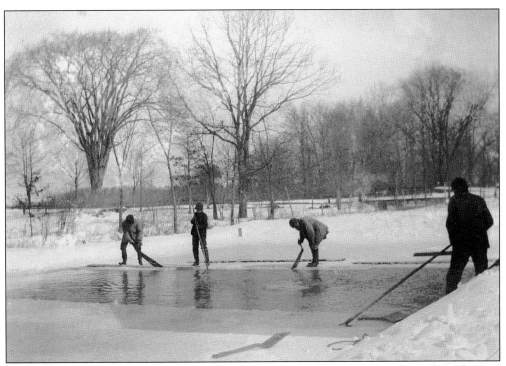

In winter, after the pond ice froze 10 inches deep or more, the town's several small ponds came alive with ice cutters. The heavy ice cakes were cut and dragged from the pond by teams of horses. The town had several of these ice enterprises.

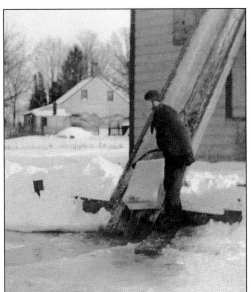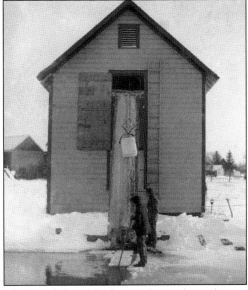

Each ice cake was guided into a chute, pictured at left, and then lifted up and into the icehouse, pictured at right, to be stored under insulating layers of thick sawdust. In the late spring and all summer, neighboring estate owners were prime customers.

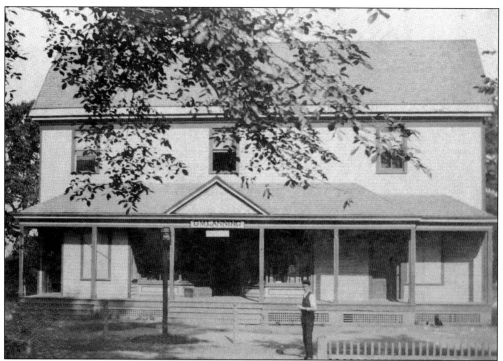

G.W. Lanning's store on Ridgedale Avenue near the village center, the town's main emporium, was photographed soon after it opened in the mid-1870s. Goods were offered at "New York prices."

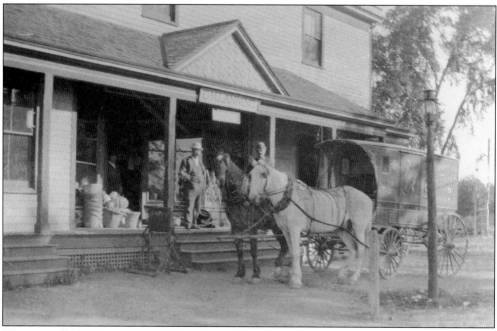

Wagons pulled up to Lanning's front porch all day to stock the shelves. Especially welcomed by children was the wagon of J.C. Boise, the Candy Man. The Elks Club now occupies the Lanning building.

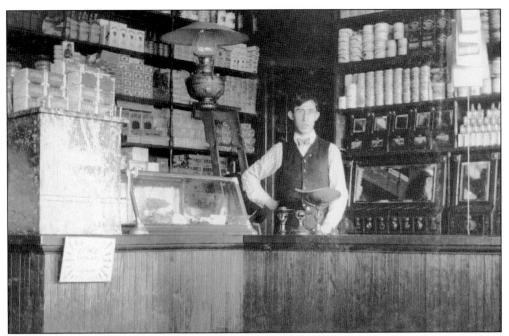

Carefully watched by young clerk Tom, fascinated village children wished they had a penny as they gaped at display cases filled with candies and cookies. In season the store also had a full selection of Christmas toys and other gifts.

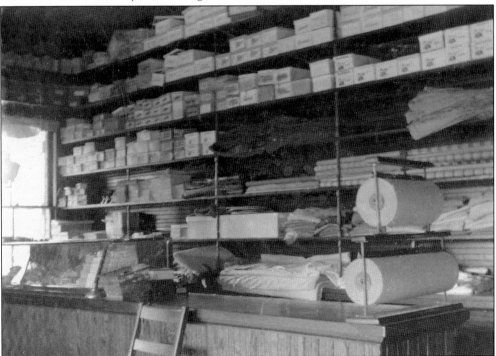

Parents saw the wistfulness of their children, but they had to look beyond the candy and trifles to shoes of nearly all sizes on the top shelf, bolts of cloth, canned goods, and hundreds of other wares. Purchases were wrapped in paper from two huge dispenser rolls on the counter.

The Afton Post Office, which opened in 1879 in Lanning's store, attracted people who walked to the village center to get their mail and usually bought a few things other than stamps. This part of the old post office survives in the Florham Park Historical Society.

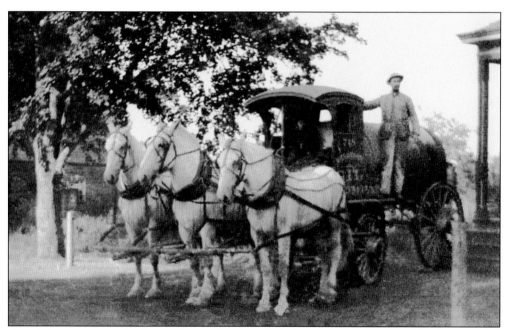

A weekly main event in the 1890s was the arrival of the grimy kerosene wagon to supply fuel for homes and the village streetlights. Boice's candy wagon smelled better and was not oily, but even children knew the importance of kerosene.

20

Lanning's major competitor for many decades was the N.A. Felch store on the corner of Ridgedale Avenue and Brooklake Road. It is shown here when it was Tony Bertello's well-known antiques shop, before it was razed to make way for a bank building.

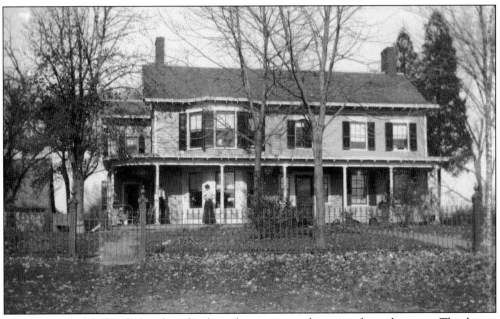

The George Felch family lived in this large house across the street from the store. This house also fell to the "progress" of the 1950s and 1960s that eliminated much of the town's heritage near the Florham Park center.

One of the many broom factories in town was in this building at the corner of South Orange Avenue and Hanover Road. The building was also a store, a post office, and a private home before it became the beginning portion of the large, modern Afton Restaurant.

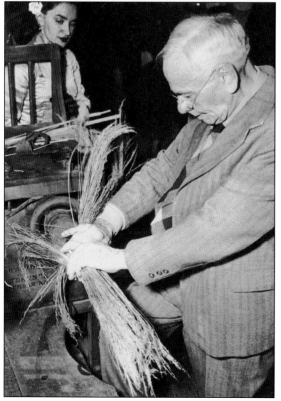

Monroe Hancock, a descendant of one of the town's earliest families, used his father's broom-making machine to make a sweeper at the Florham Park Historical Society in 1950. By then, the commercial manufacture of brooms had been long gone.

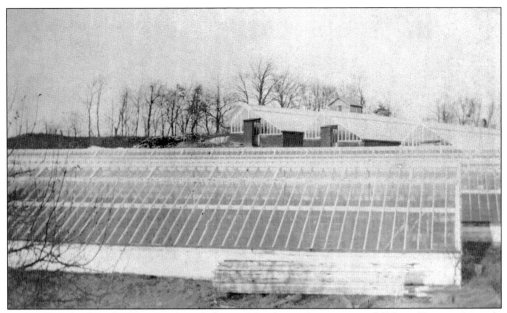

Two recently found photographs of the 1890s show the extent of Edgar Hopping's early greenhouses off Columbia Road. Hopping began the enterprise in 1888 and built facilities for growing roses under 55,000 square feet of glass.

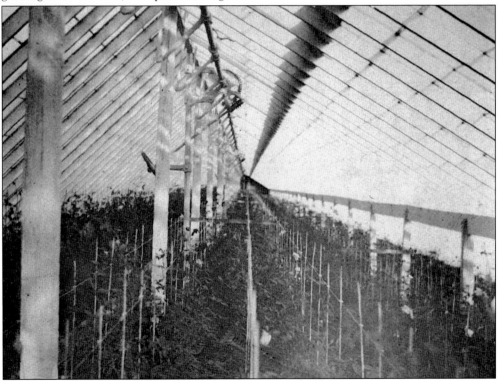

Hopping's enterprise was said to be the largest greenhouse operation in Morris County—a considerable statement because of the county's national rose leadership. Several competitors built in Florham Park in the 20th century.

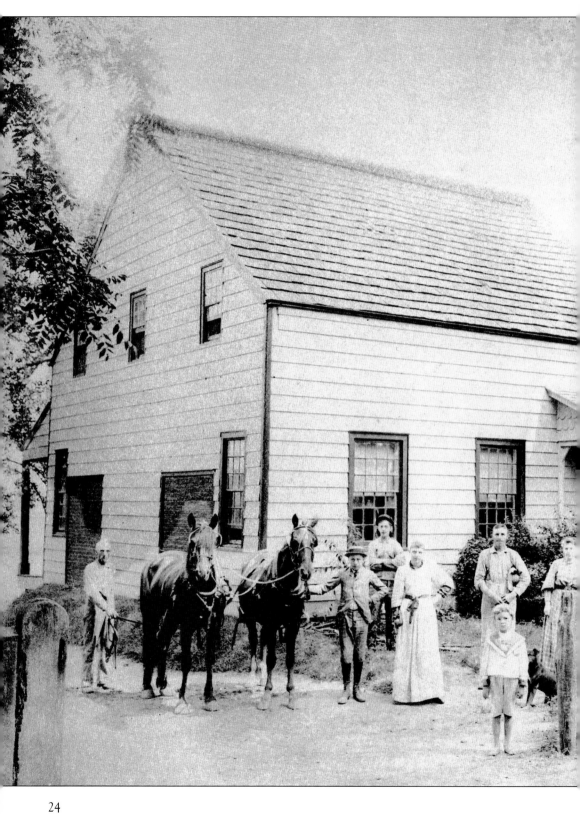

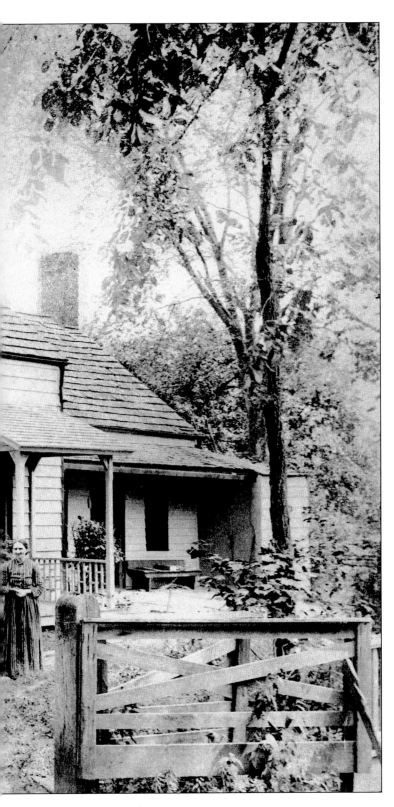

Afton's economy in the 1890s was dominated by farmers who plowed broad fields, grazed cows, plucked fruit in orchards, and grew vegetables. This workaday scene on the large James family farm at 155 Ridgedale Avenue was taken c. 1895. Farmer William James Sr., patriarch of the large family, is at the reins. Posing on the lawn were, from left to right, Albert James, Burton Westervelt, Ida James Westervelt, William James Jr., Clifford James, Lydia James, and Laura Tucker James.

Education began as early as 1805 when the Genungtown School was built in the village's southern end at East Madison and Greenwood Avenues. Students from part of nearby Madison also attended the school. It was a long walk for boys and girls who lived near Afton's center. The school was torn down in the 1920s.

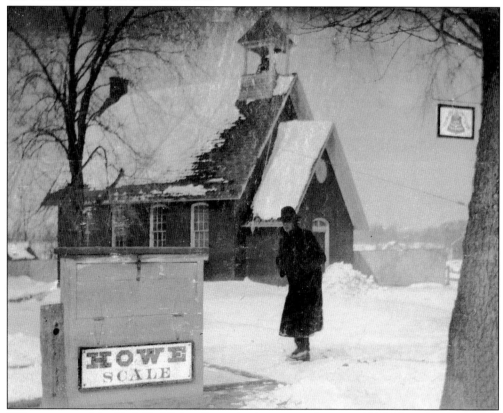

Villagers opened the Little Red Schoolhouse in the center of town in 1866. The school was little changed by 1895. The Howe Scale and the telephone sign on the tree showed that Lanning's store kept pace with the world. This was the first village telephone.

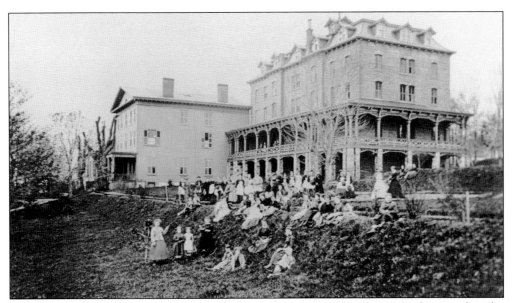

The Sisters of Charity opened Saint Elizabeth's Academy in 1860. This 1866 photograph is the earliest known depiction of the academy and its students. The structure on the right was added after the academy began to grow.

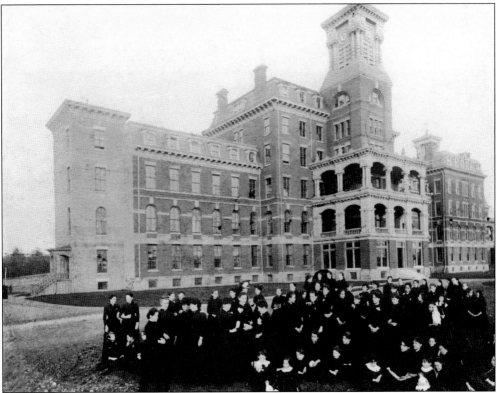

When this scene was taken in 1886, the Sisters of Charity had moved (in 1880) from the early buildings to this imposing structure atop the hill overlooking the Delaware, Lackawanna & Western Railroad, where a new depot set a name for the area: Convent Station.

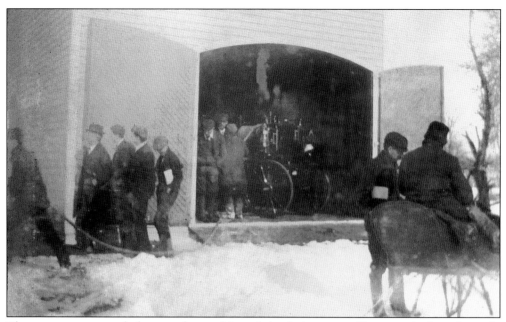

The computer-restored photographs on this and the facing page offer a rare look at the early Afton Fire Department, predecessor of the Florham Park Volunteer Fire Department. Above is the company headquarters and the horse-drawn, manually operated pumper.

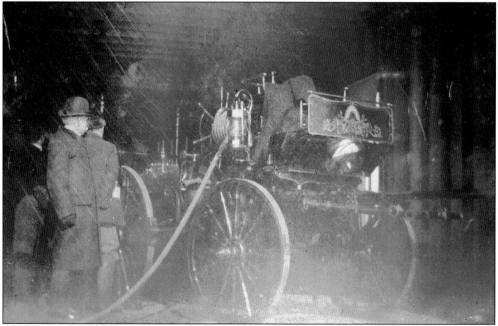

Horses were stabled in nearby barns and had to be raced to the firehouse when an alarm was sounded by the bell in the cupola on the roof. After horses were attached to the hose cart, many minutes passed before they were trotted off to the blaze.

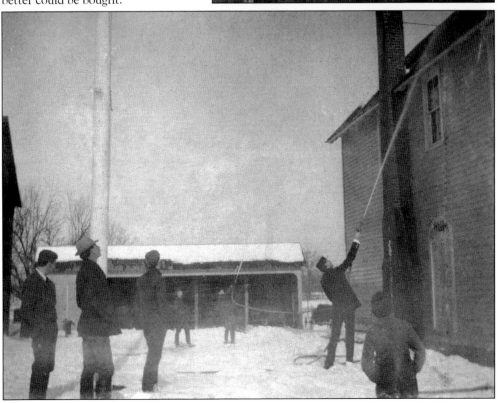

The fire headquarters, right, was built when the department was organized in 1898, a year before Florham Park Borough was born. The new borough's organizational meeting was held on the second floor. Below, a fireman handled the thin nozzle to demonstrate how high a stream of water could be pumped by the available pumper. It was far from adequate, but nothing much better could be bought.

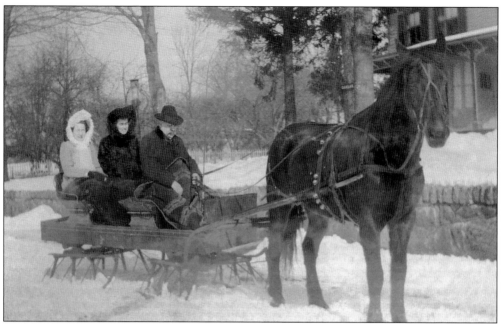

Horse-drawn sleighs were the comfortable wintertime travel choice for members of the Hopping family and all others with sufficient means. Rough plows cleared only the main roads of the widespread village.

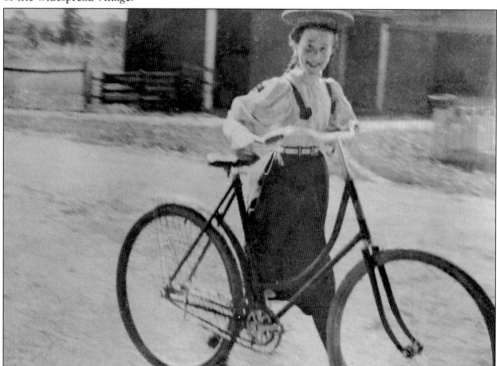

When the roads were cleared of snow and the rains had not turned them into mud, the preferred way to travel was on a bicycle, as shown by an Afton village schoolgirl, likely either a Hopping or a Lanning.

Two

Why Flor-ham Park?

This occasion, the wedding of Florence Vanderbilt and Hamilton McKeon Twombly in 1887, was the first official linking of the names Florence and Hamilton. The couple, worth an estimated $70 million, named their 1,000-acre Afton estate "Florham," using the first syllables of their first names. In 1899, the Twomblys and Dr. Leslie D. Ward, millionaire owner of Brooklake Park, agitated for a new borough to be split from Chatham township and called Florham Park. Afton villagers amiably expressed their willingness. The Twomblys in turn agreed that the "Park" in Afton's new name commemorated Dr. Leslie Ward's widespread estate called Brooklake Park.

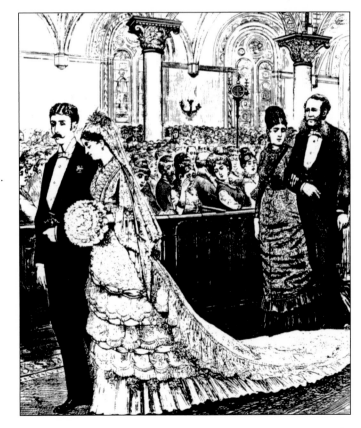

Florence Vanderbilt, granddaughter of famed railroad and steamship tycoon Commodore Cornelius Vanderbilt, brought more than $50 million to her marriage to Hamilton Twombly. She lived the life of an American queen, dividing her time between a New York City apartment, a huge home in Newport, Rhode Island, and the castle-like mansion in Florham Park. She died in Paris in 1952 at age 99. Mrs. Twombly is shown here in her mid-nineties. The Twombly mansion, located on a small hill, was visible for long distances before trees grew tall. This photograph shows the home c. 1897, the year it was completed. After coming in 1887 to be near the numerous millionaires who lived in the area, the couple built the 100-room mansion modeled after King Henry VIII's Hampton Court palace. Their estate was almost fully in Florham Park.

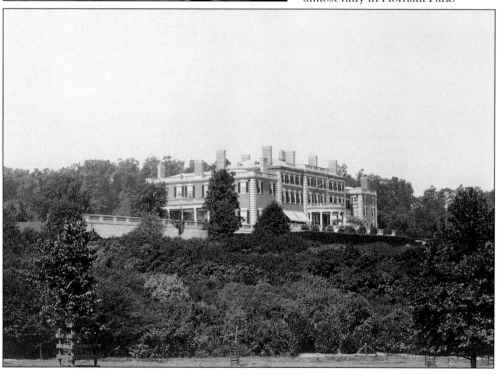

Florence Twombly willed the estate to her daughter Ruth Twombly, who died in 1954. The mansion and furnishings were sold a year later. A presale open house in 1955 permitted outsiders to see for the first time the interior opulence. The mansion itself soon after became the core of Fairleigh Dickinson University's campus.

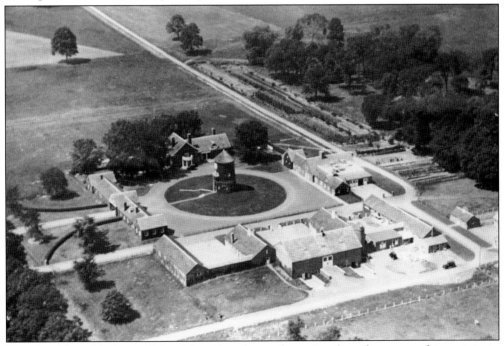

Hamilton Twombly fancied himself as a "gentleman farmer" and sought to prove his rusticity in such ways as this well-equipped and highly expensive dairy facility. Esso (now Exxon) Research and Engineering Company bought most of the farm area after Ruth Twombly's death.

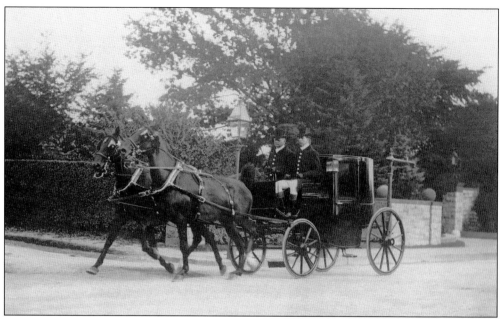

The Twomblys were seen often on drives through their farm or on roads leading to Morristown or Madison. The uniformed driver and footman lent emphasis to the family's aristocratic pretensions. They used the snug carriage on inclement days.

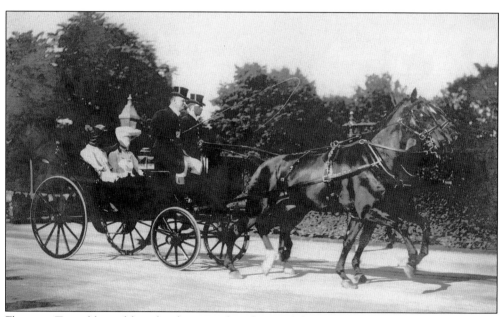

Florence Twombly and her daughters preferred one of their many handsome open carriages. Either way, high-stepping matched teams provided the horsepower. High-hatted attendants provided the grandeur.

When the stock barn was finished in the fall of 1893, the Twomblys staged a barn dance. The *Electric World* pictured this display of electrical splendor, lit by current from an electrical generator that cost $6,000. The rest of the village of Afton was lit by kerosene lamps until nearly 1910.

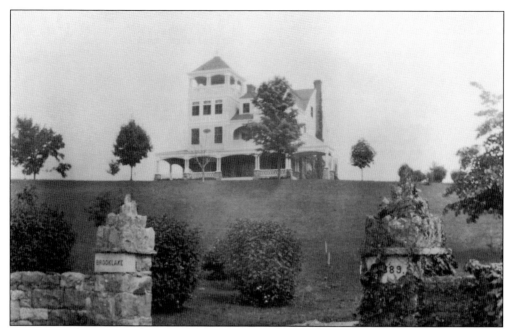

Born in Florham Park (then Columbia) in 1845, Dr. Leslie Ward was John Dryden's chief aide when Dryden founded what would become the Prudential Insurance Company in 1873. Ward lived in Newark but acquired some 1,000 acres of land and built this three-story wooden house for a summer home.

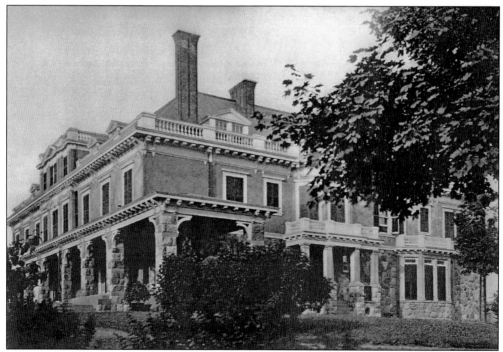

When the wooden structure burned c. 1895, Leslie Ward built this showplace on high ground overlooking his man-made lake. In 1923, a group of wealthy sportsmen acquired the mansion and large surrounding acreage to form the nationally known Braidburn Country Club.

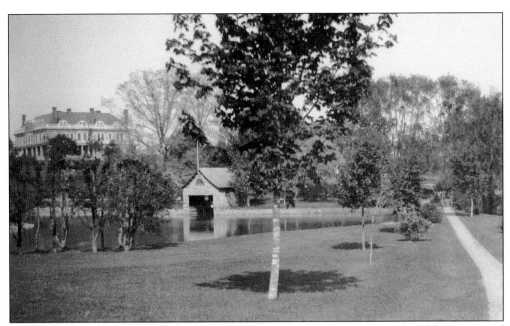

The Ward estate, called Brooklake Park, was a place of beauty. It was relatively modest compared to the Twombly's showy palace, but Leslie Ward's taste ran to long vistas, a lake, narrow carriage roads, and footpaths that wandered across many parts of the estate.

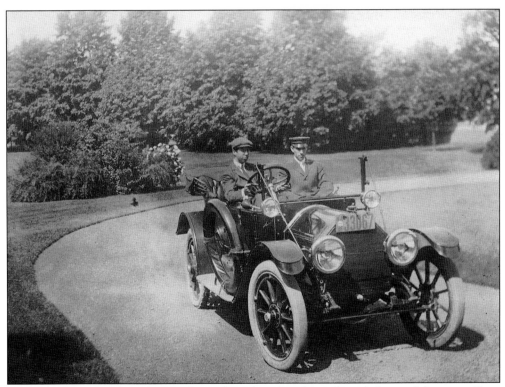

Carnot Meeker Ward, Leslie Ward's nephew, loved to drive through his uncle's estate. He is shown here at the wheel, as family chauffeur Robert Ward Sr. agreeably became a passenger.

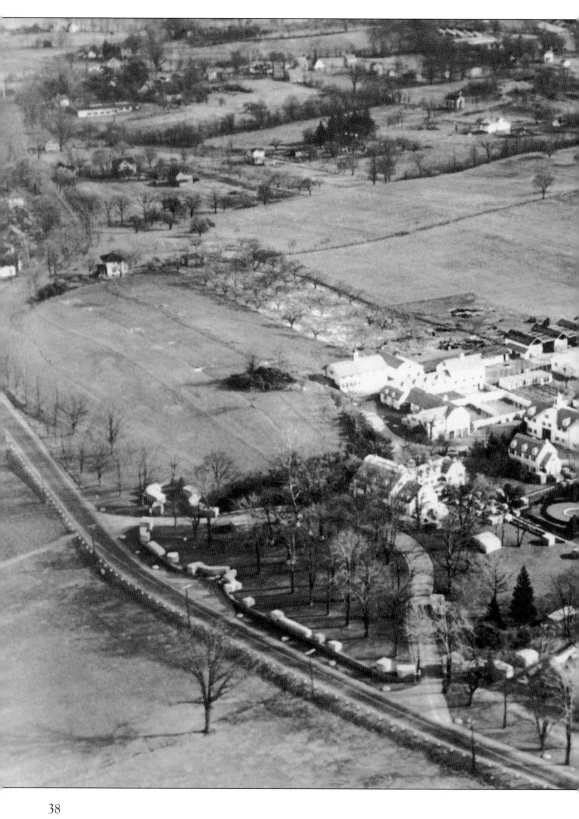

Florham Park had a third millionaire, Lloyd Waddell Smith, whose estate ran along Ridgedale Avenue for nearly a half mile. Smith was born in 1870 in a mansion called Boxwood Hall. When his family lost the property in 1881, Smith vowed he would someday buy back the estate. After working his way through Andover Academy, Harvard University, and Yale Law School, he made a fortune and re-acquired the estate in 1907. Nearly all of the open land in this photograph was Smith's. Today, practically all of it is covered with houses.

No Florham Park resident has ever been more deserving of lasting acclaim than Lloyd Smith, yet little written material survives and photographs are extremely rare. This formal photograph indicates an austere character rather than the warm-hearted man whose benefactions to his town and his nation were scarcely known. Smith grew up as a farm boy, worked for his education, and preserved his fortune by selling his investments just before the New York Stock Exchange crashed in 1929. Thereafter, he seldom appeared in formal dress, preferring the appearance of a poor farmer clad in work clothes and a slouch hat. He drove himself around town in an old Lincoln touring car. In apple harvest time, he sold apples on his front lawn. Smith was the genius and chief benefactor behind the preservation of the Jockey Hollow area near Morristown, where George Washington's army endured the horrible winter of 1779–80. He owned 1,100 acres of land there, including the camp site some 2 miles south of Morristown. He became chairman of a committee appointed to preserve the region, and in 1933, thanks largely to his efforts, Jockey Hollow and the headquarters mansion in Morristown were dedicated as the first National Historical Park in the United States. Smith also gave his large and exceptionally valuable collections of George Washington materials and Native American artifacts to the national park.

Locally, Smith's generosity was relatively modest. Residents still recall his "gifts" to them of the right to pick strawberries and cut asparagus on his estate. He donated moderately to local groups and gave land for two churches. His beloved mansion Boxwood still stands, but houses built closely around it obscure most of the home's historical and cultural aspects.

Three

Sweet, Slow Change

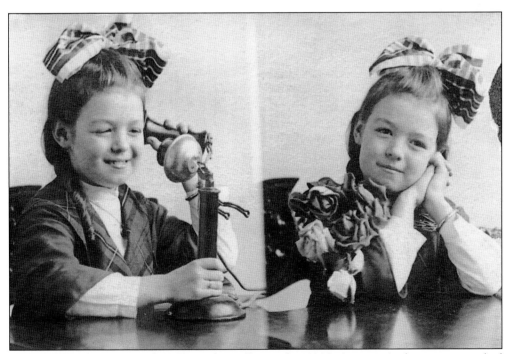

"Hello, Central? Give me a line," was what callers said in 1910. A woman's pleasant voice asked for the number wanted and then linked the call to the right line. If it was a party line rather than a private line, the message was shared. Using a telephone was serious business for this little girl, believed to be a relative of the James family. Apparently, she was pleased with her call. So it went in Florham Park before and after the declaration of independence from Chatham Township on March 20, 1899.

Jesse S. Keys became Florham Park's first mayor when the new borough council organized. The community on organization day officially had 808 inhabitants in its 8-square-mile area. Of the borough's 14 miles of roads, only three were macadamized. Mayor Keys was well-to-do thanks to his box factory, located on the rear of his property on Greenwood Avenue. The factory turned out as many as 50,000 boxes each day and employed 30 people. Keys died in 1902. His box factory was destroyed by fire in 1909.

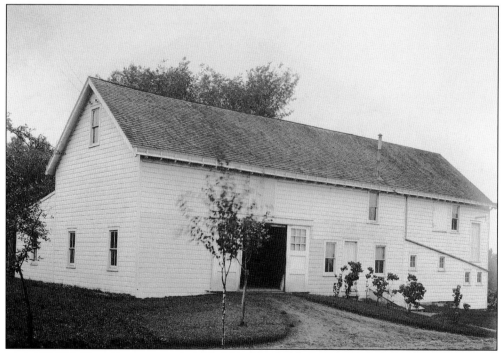

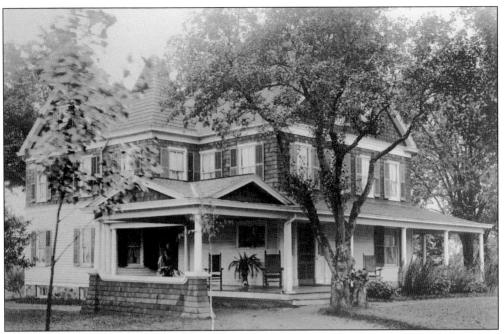

Jesse Keys and his family lived comfortably in this large, shingled Victorian House, complete with rockers and large plants on the broad veranda. A portico for wagons and buggies offered protection in inclement weather.

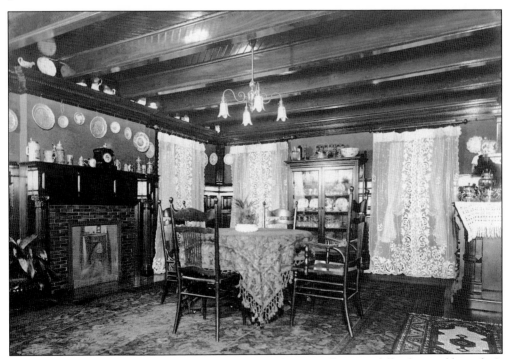

Inside the Keys's residence, the rooms were large and warm, albeit woefully cluttered by today's standards. This is the dining room, where lace curtains and the lace tablecloth vied for attention with diverse bric-a-brac. The chandelier tells of early electrical illumination.

No one, not even Mayor Jesse Keys, was more respected than "G. Pruden," the name that noted teacher Geneva Pruden wrote on the blackboard to start each school year. She came to teach in 1897 and earned respect as a strict disciplinarian and an innovative teacher.

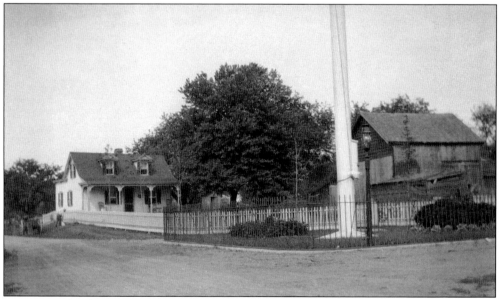

Geneva Pruden lived in the little white house behind the white picket fence, across the street from her much-loved school. It was essentially the town center, close to the Liberty Pole at the intersection of Ridgedale Avenue and Columbia Turnpike.

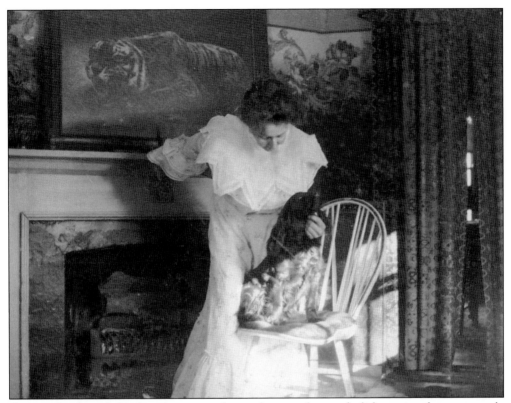

Geneva Pruden likely thought posing for a photograph was foolish vanity, but a recently discovered picture in a seldom seen family album shows the beloved teacher posed with her pet dog.

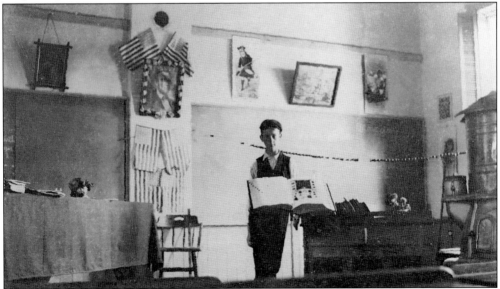

Vital to the school was Mr. Clancy, the janitor who in this picture seemed scarcely old enough for his important tasks. He kept the room clean and made sure that teacher Geneva Pruden's things remained in the same order that she left them.

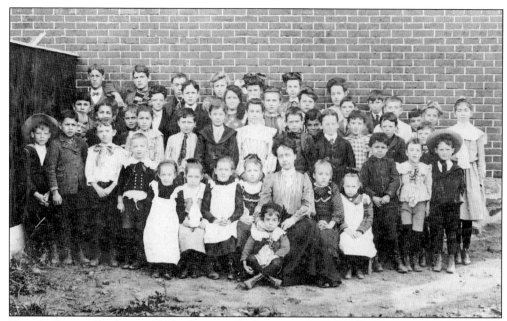

Here is Geneva Pruden in 1902, above, with the one-room school's entire student body. She taught them all and loved them all. Whether she is holding down a rambunctious boy beside her or is hugging him may never be known. In the class that graduated from Florham Grammar School in 1909, pictured below, the girls outnumbered the boys five to one. Boys were needed on area farms and few of them completed even eight grades of schooling.

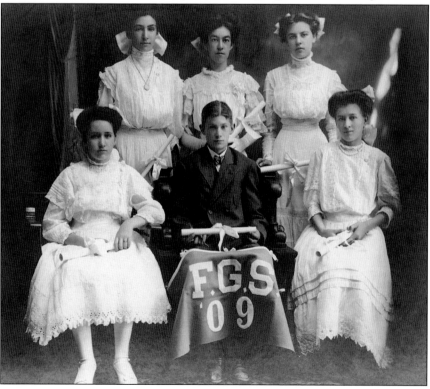

When the borough opened its new, two-story red brick school building in 1914, adjacent to the little one-room school, the latter had been relegated to auditorium status, to be used only for holiday and patriotic commemorations.

Two teachers handled all students and all subjects in the new school, where a typical class was about 35 pupils. Geneva Pruden chose grades five through eight. She and the second teacher, Eleanor J. Lum of Chatham, are in the rear of the room.

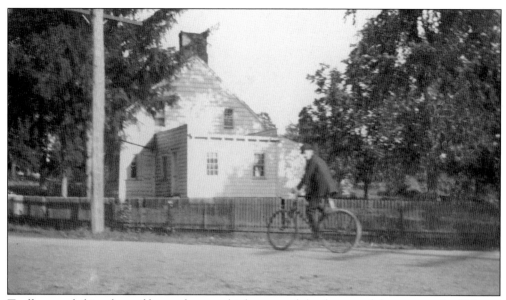

Traffic, mostly bicycles and horse-drawn vehicles, moved slowly around the noteworthy "Liberty Pole," the village flagpole. In the photograph, a cyclist moves eastward on the turnpike, past the Clancy house. The pole there is an electric pole, not a flagpole.

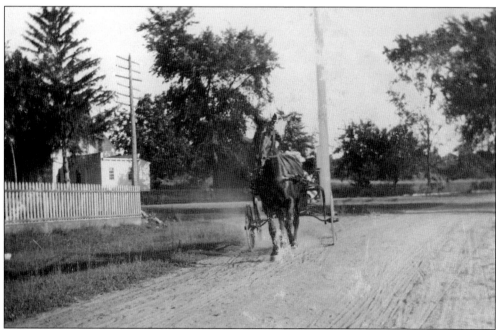

The flagpole behind the buggy was raised in 1896. It was more than 100 feet tall and cost $286.20 to buy, shape, and erect. Road surfaces were sandy soil, marked with small ruts from passing horse-drawn vehicles. Geneva Pruden's fence was on the left.

Florham Park c. 1910 was far enough from "the city," New York, to make it seem bucolic. The group pictured is identified as "Felix Adler's Fresh Air" children, presumably from New York. They are definitely in Florham Park; note the distinctive kerosene lamp.

The young adults in this photograph called themselves "the Indians," but the reason for the name has been lost in time.

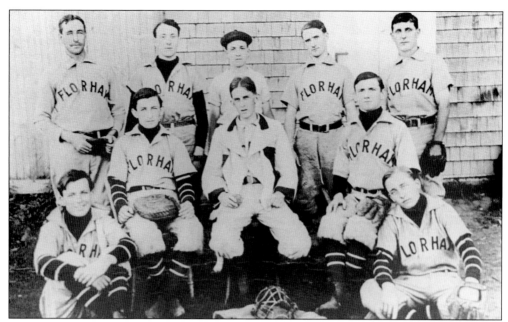

This 1905 "Florham" baseball team may have represented Twombly's Florham Farm. The last names of the players are, from left to right, as follows: (front row) Rafter, Daniker, Bardon, Keating, and Steitz; (back row) Johnson, Grove, VanVoorhis, Hart, and Hayes.

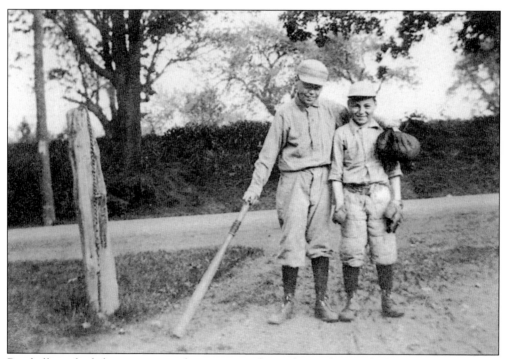

Baseball reached down to young boys even without the mighty umbrella of a Little League organization. Fully equipped with uniforms, gloves, and bat, Cliff James and a friend comfortably struck a big league pose sometime before 1910.

William James Sr. and his wife Laura Tucker James paused in their arduous farm chores to pose c. 1910. Their large multipurpose farm, shown below, fronted on Ridgedale Avenue. The barn and chicken coops were located close to the house and were very weathered and quite old. Chickens, a must on every farm, scratched noisily and successfully in the barnyard area.

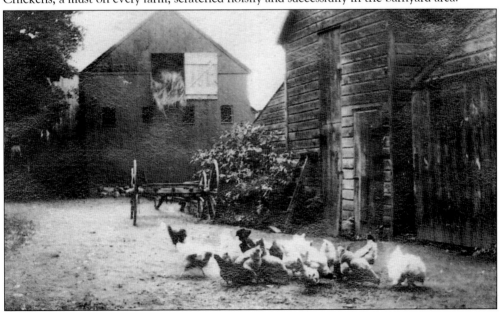

The pictures on this and several succeeding pages are turn-of-the-century photographs owned by James family descendants. Cliff James, the ballplayer of page 50, tends a grindstone as one of his farm chores, in the above photograph. Pearl James, cousin Helen Barton, and an unidentified friend pose in a cornfield, below on the left. Below on the right, James family cousins Marion and Lillian Teed smile in front of the family well, every farmer's treasure.

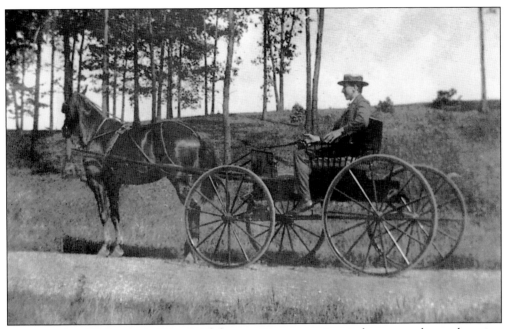

Whoever had the excellent camera and the patience to use it properly preserved a good portion of the James family at work and at play. Dressed in his Sunday best, one of the James boys, probably Albert, halted his one-horse buggy to oblige the photographer.

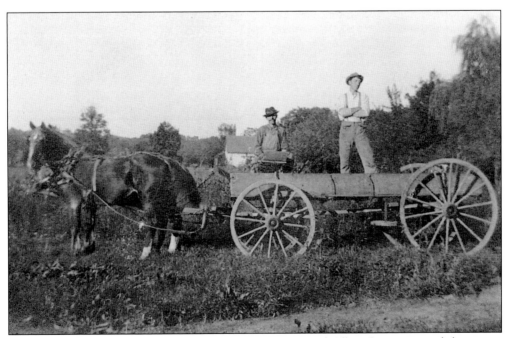

Equally obliging to the photographer, William James Jr. and Albert James stopped their team and farm wagon on the way to pick up hay in the fields or perhaps to pluck fruit in one of the orchards on the extensive family farm.

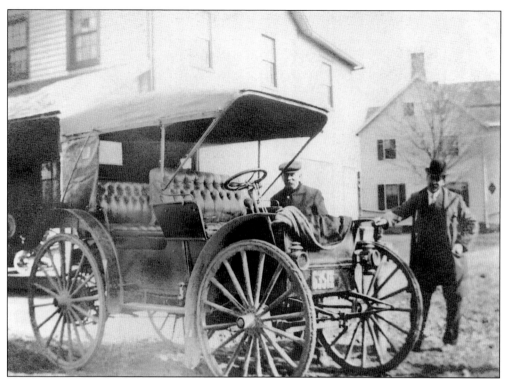

Except for the Twombly family's Rolls Royces, the James family and friends owned some of the area's earliest gasoline-powered automobiles. On the right, William James Jr.'s father-in-law, Fordyce Kithcart, visited the farm before 1910 to show his wagon-wheeled automobile.

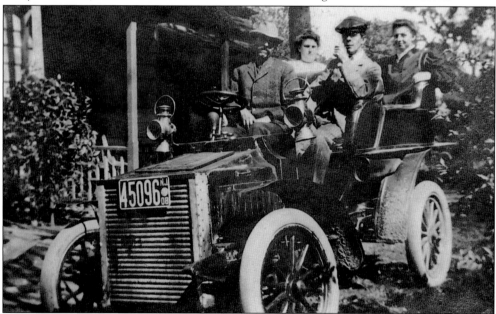

Ready for a drive through the northern New Jersey countryside in 1908—note the license plate—are Agnes James and Ida James Westervelt in the back seat, and Albert James and Burton Westervelt in the front seat.

The Hopping family album reveals some of the important times for members of that family. Elaborately coiffed Daisy Hopping sat for this picture on Christmas Day, 1901. She wore her best high-necked white blouse to the studio.

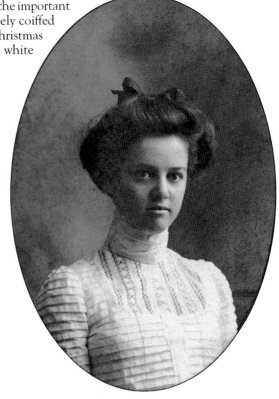

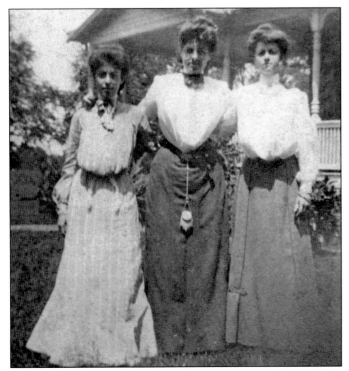

Nearly two years later, on August 1, 1903, Daisy Hopping joined friends Nell Sheridan and Eva Freeman in another portrait taken by a professional photographer. Two of the young women wore fashionable shirtwaists and skirts pinched at the waist.

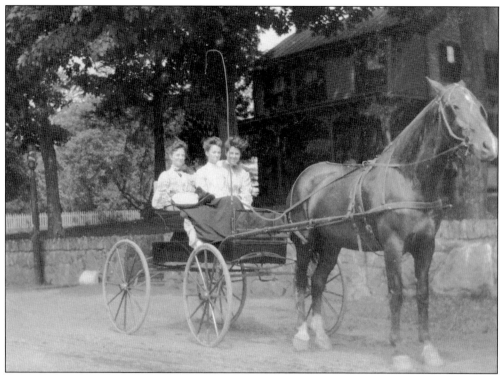

On summer evenings or Sunday afternoons, young men and women rode through town and into the countryside, to see the scenery and possibly to find members of the opposite sex. The three young women above, likely the trio pictured on page 55, appeared in their sleek buggy. At about the same time, three young men identified as Floyd (possibly Hopping), Fred Ely, and John Hughson set out in their two-seated buggy to see whom they, in their turn, might meet.

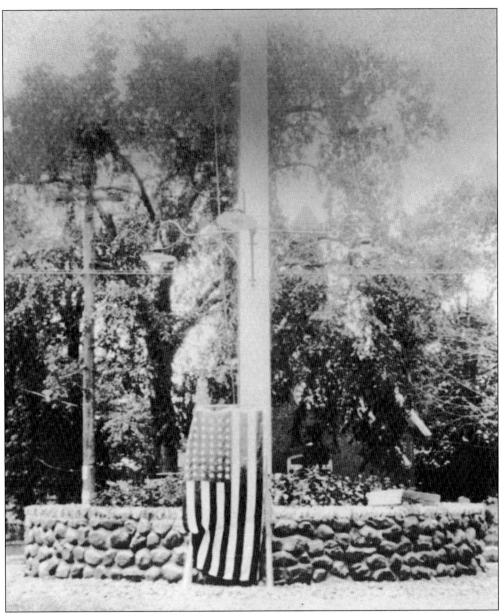

After World War I ended, intensified automobile traffic raced through town. Ruth Twombly and schoolchildren donated funds to protect the flagpole at Ridgedale Avenue and Columbia Turnpike from early "road ragers." The stone wall was built and dedicated in 1921. The imposing wall was removed in 1957 to open the intersection to ever-increasing traffic.

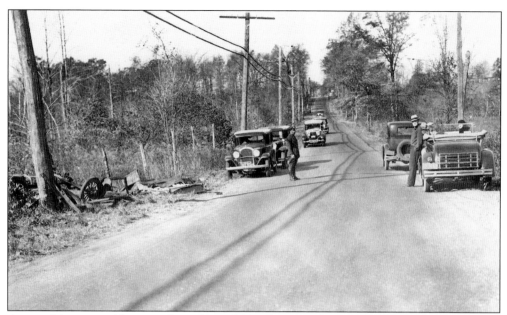

Automobiles inevitably created accidents. It is uncertain whether the scattered debris on the left in the above picture represented an automobile that had hit the pole or merely automobile junk dumped on the site sometime in the 1930s. Small matter, it created a modest traffic jam.

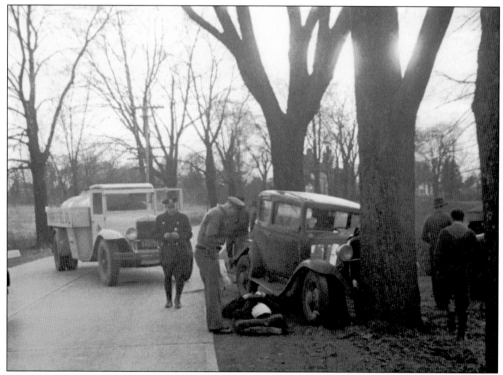

There was no question about this accident on Hanover Road. It left a victim stretched out on the side of the road to await whatever emergency help could be summoned from Madison or Morristown. A truck served as a traffic block.

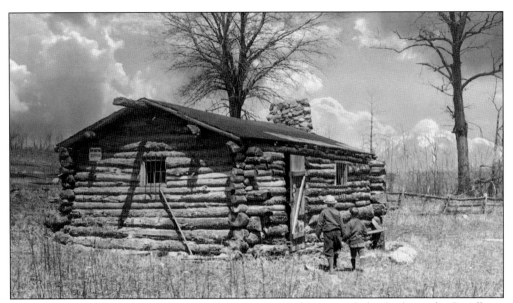

If ever there was "man's place" it was this trapping and hunting lodge built on the Braidburn Country Club property in the early 1920s. It was a small, rustic but well-built log cabin, erected close to the Passaic River marshlands.

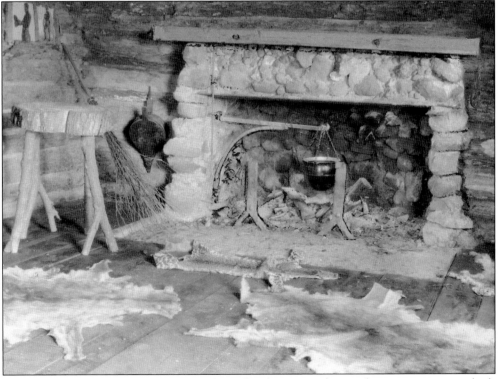

Inside, the one-room lodge featured a huge fireplace, complete with an iron pot on which skilled sportsmen could cook a rich stew. Large animal pelts covered the floor. All traces of the lodge have disappeared.

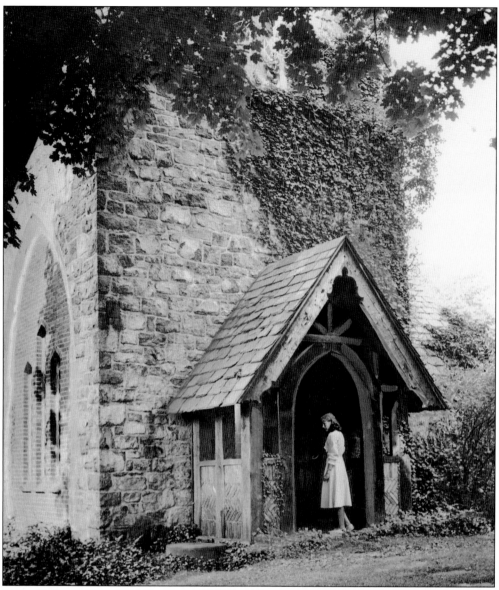

Little Hollows Church of Prayer at 83 Ridgedale Avenue, a slightly known Florham Park treasure, was built in 1931 by Rev. Albert M. Farr. He and Mrs. Farr modeled the little building on roadside churches that they had seen on visits to England. The stone for the walls came from Newton in Sussex County. Ivy now covers much of the little church.

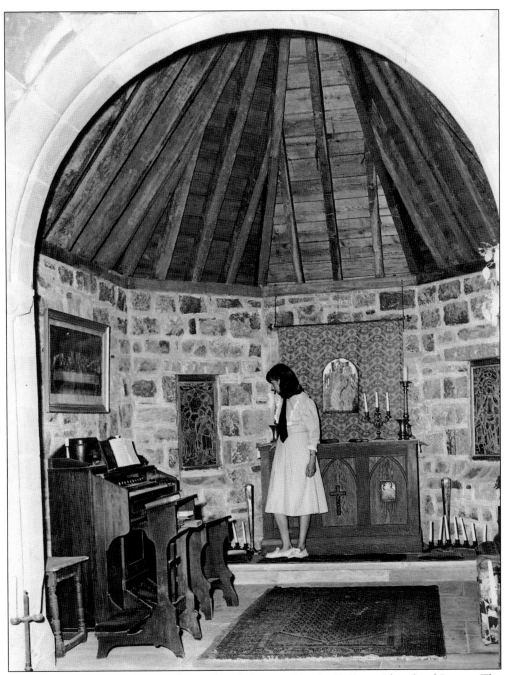

The church interior enhances the medieval theme of Little Hollows Church of Prayer. The organ and altar have been used occasionally for weddings. Light sifts through diamond-patterned windows. The church is open only on appointment. Rev. Albert Farr, an Episcopalian minister, ran for governor of New Jersey in 1920.

Symbolic of the lawless Roaring Twenties was mysterious Canary Cottage on the hill, once the spacious Ridgedale Avenue mansion of George W. Felch and during Prohibition years, the site of a well-attended, illegal speakeasy.

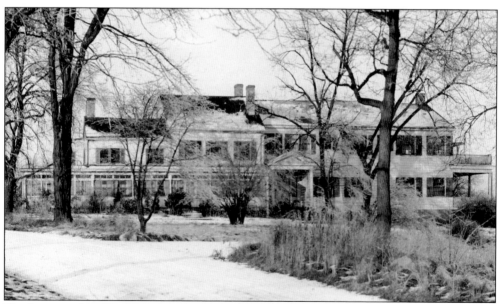

The house at 244 Brooklake Road, now a pleasant residence, was a notorious gambling and 1920s drinking hangout known as Churchill Downs. This is how the house appeared in the 1920s. Subsequent alterations have reduced it greatly in size and, of course, eliminated the illicit activities.

Four

FLORHAM PARK, RFD

In the early days of World War II, Bogert Cox paused to pick up his mail at his roadside mailbox. The Coxes still received their mail via rural free delivery—as did all of Florham Park. It was sorted and delivered by the Madison Post Office. The post office in Lanning's store had disappeared decades before, and RFD signified a village not yet ready to grow. The borough's population in 1940 was approximately 1,600 men, women, and children.

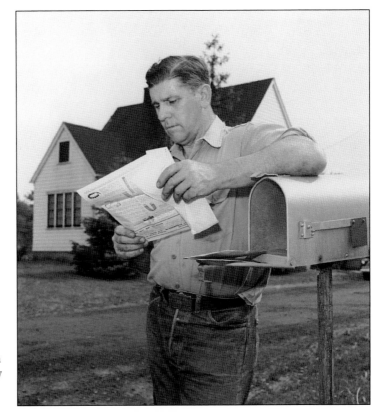

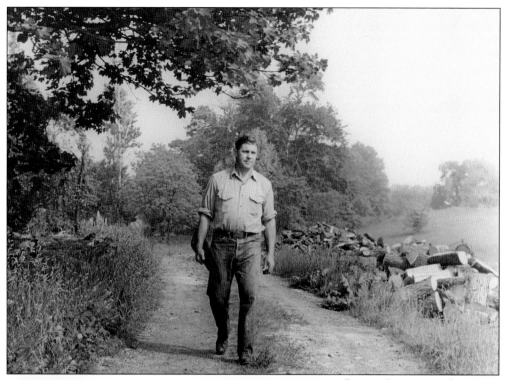

Bogert Cox, an employee of E.I. Du Pont during World War II, agreed that he and his wife, Eleanor, would enact for the company magazine a typical wartime day on a small farm. Clad in jeans, Cox walked by a woodpile he had chopped earlier in the day.

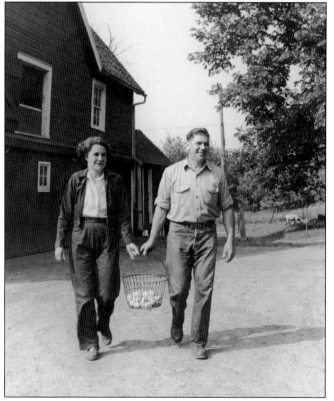

After lunch, Bogert and Eleanor Cox carried eggs laid by their hens. Other scenes in the series of photographs showed Cox digging postholes, shearing a sheep, and performing other tasks necessary to keep a small farm running smoothly.

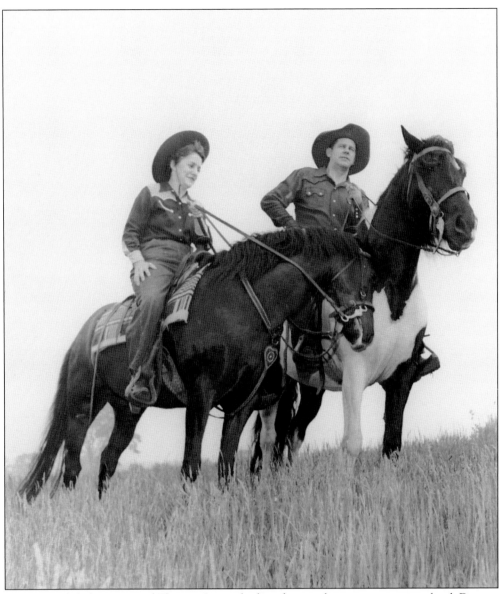

As the day faded, Bogert and Eleanor Cox rode their favorite horses across pastureland. Despite the look of vast open country, this scene was photographed in Florham Park. In the 1940s, the borough's fields stretched far and wide, offering ample space for cross-country rides.

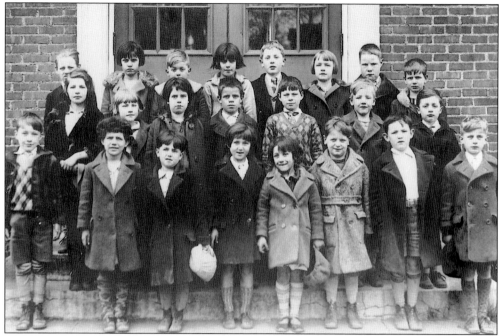

Increasing numbers of young schoolchildren in the 1930s gave evidence that Florham Park's population was rising, however slowly. This is a student group at Ridgedale School *c.* 1935. Their clothes did not indicate that prosperity was just around the corner.

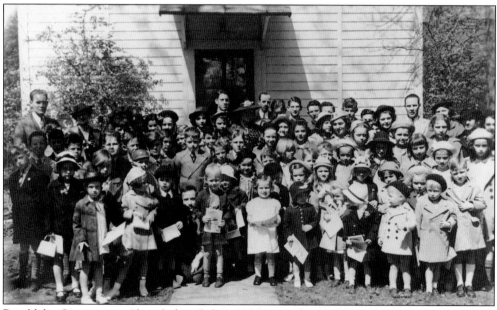

Brooklake Community Chapel, founded in 1926, served a broad cross section of the town's young for many years. In addition to Sunday school, typified by this group in 1932, the chapel lent rooms to Boy Scout, Girl Scout, and other youth groups for many years.

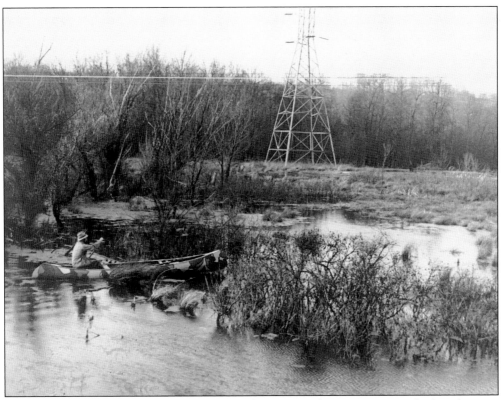

In the late 1930s, adults and children practiced pursuits such as canoeing on the broad watery marshes near the Passaic River. Spring rains caused the river to spill across the marshes in an area known as the Freshet. In winter, ice created a huge outdoor skating rink.

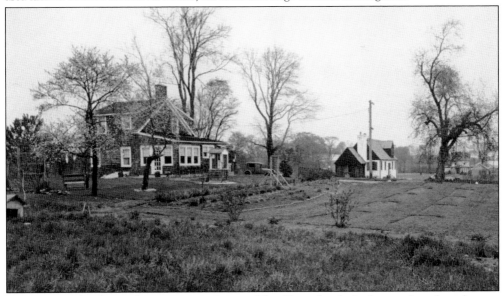

Open space also fostered extensive gardening. The Kurtz family had several garden plots on its small farm beside Brooklake Road. Today, all of this broad area is covered with homes built since World War II.

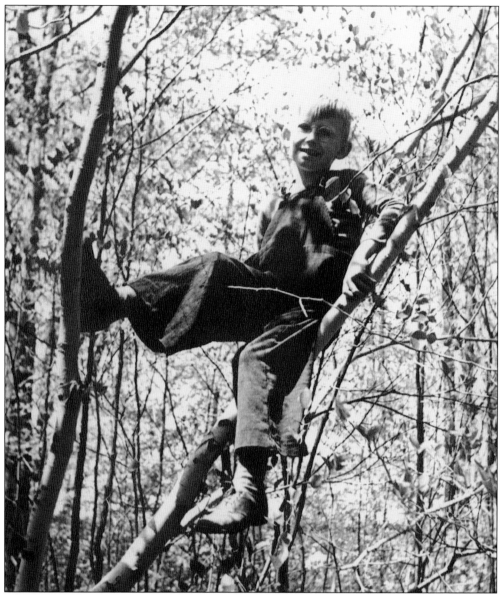

The national fervor of World War II gripped Florham Park's adults and children. It was a time for whatever simple pleasures could be enjoyed against the pressures of war. The youngest member of the Kurtz family, Stu, climbed a tree to survey the landscape. He joined young neighbors to explore and to use as much as possible of the world within direct contact.

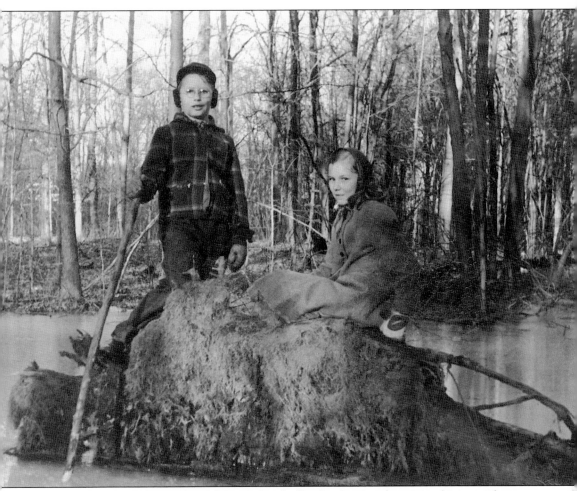

In wintertime, nearby ice-encrusted Cory's Pond offered a chance to examine the roots of a tree blown down by an autumn hurricane. Until developers took over the pond, it was one of the town's most popular skating areas.

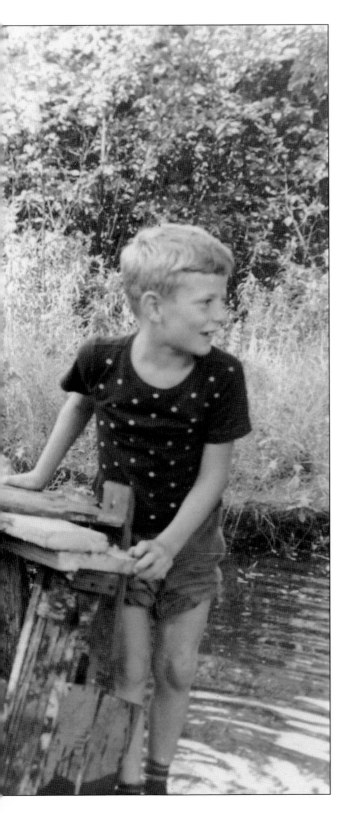

Cory's Pond? It might as well have been the Mississippi River, as Stu Kurtz and a friend embarked on their homemade raft for a floating expedition. Cars sped noisily by on Columbia Turnpike adjacent to the pond, but it was not difficult for the boys to muster up dreams to match those of old-time river explorers— naturally on a small scale to match the muddy little pond.

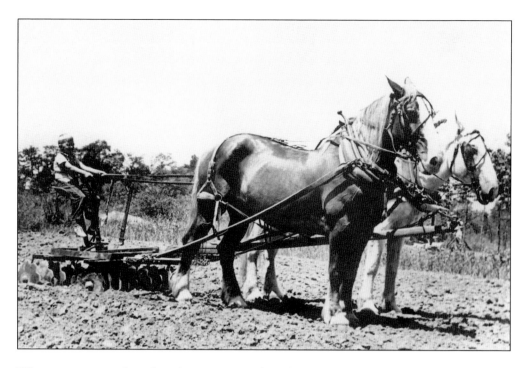

What greater joy is there for a farm youngster than the chance to take his father's place on the seat of a harrow behind the family team? Riding the horses back to the stable was not quite as exciting, but it provided ample pride for Stu Kurtz and his cousin Florence Parks, below.

World War II touched every family. The town sent 154 young men and one woman into service. Seven of them died. The last killed in action was Pvt. Harold E. Felch Jr., right, a member of one of Florham Park's best-known families, shown here with friend Malcolm Welsh. Felch died on a battlefield in Germany late in the war. Nearly every family had its own victory garden, below, to beat the food shortages.

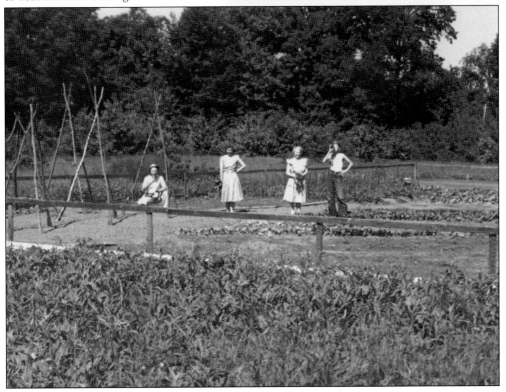

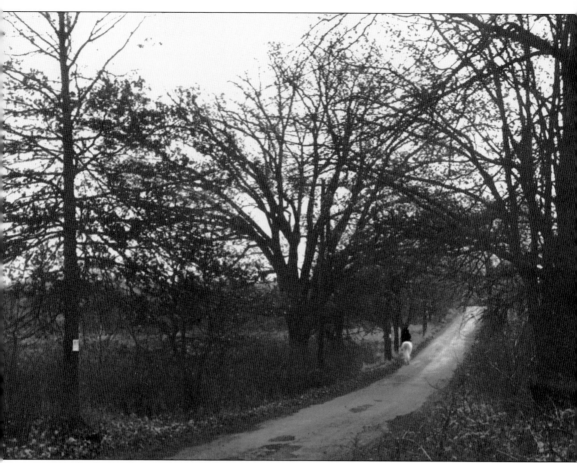

The shadows of war lifted. Florham Park people were about to experience the growing pains that would beset the nation. While they waited, they enjoyed spots such as lonely, narrow Brooklake Road as it appeared in 1945. Within a decade, houses lined both sides of this street.

Five

COLLEGE TOWN

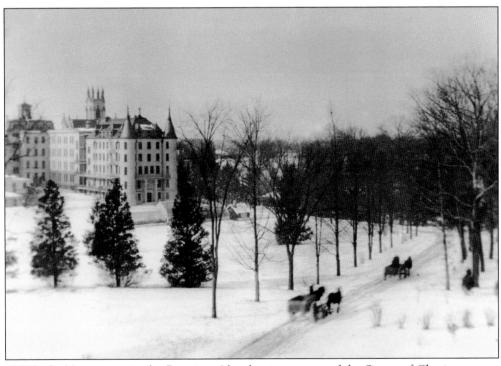

This looks like a scene in the Bavarian Alps, but it was part of the Sisters of Charity campus during a snowstorm in the 1920s. The sleighs in the foreground are in Florham Park; the tall buildings are mainly in Morris Township. On this campus in 1899 the Sisters of Charity founded the College of St. Elizabeth, the first New Jersey college to grant four-year degrees to women.

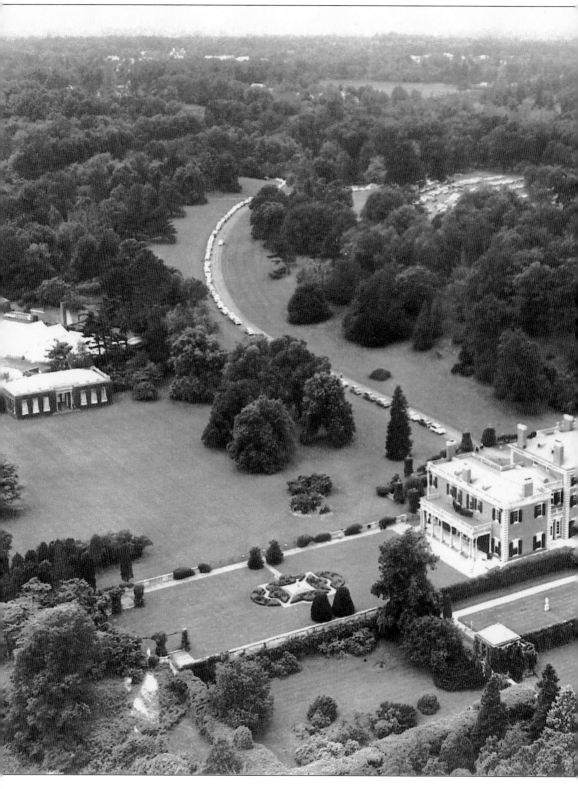

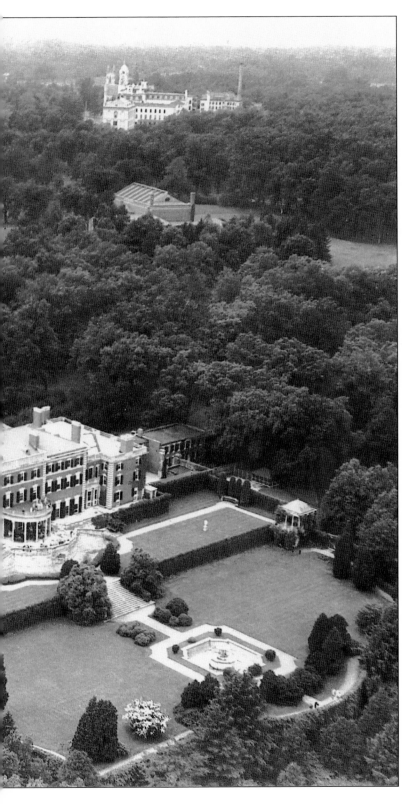

Both Fairleigh Dickinson University, in the foreground, and the College of St. Elizabeth, in the upper right, are almost entirely within Florham Park, even if the media often erroneously say that both are in Madison or, in the case of St. Elizabeth's, Convent Station. The two heavily wooded, adjacent campuses in this 1955 aerial view provide Florham Park with about 600 acres of hardwood forest. Fairleigh Dickinson has added several buildings and an athletic field, but the scene from the air has changed little since the university acquired the Twombly estate in 1955.

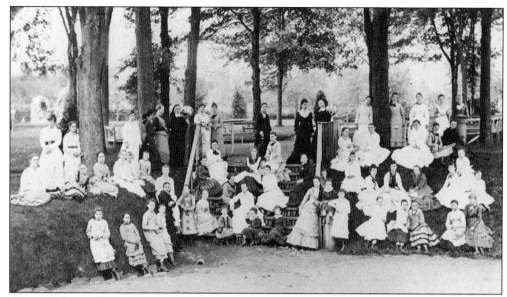

Almost 35 years before Florham Park gained municipal boundaries and a name, the Sisters of Charity conducted an advanced program for young women at the Academy of Saint Elizabeth. The student body of 1880 sat for a portrait beneath tall trees.

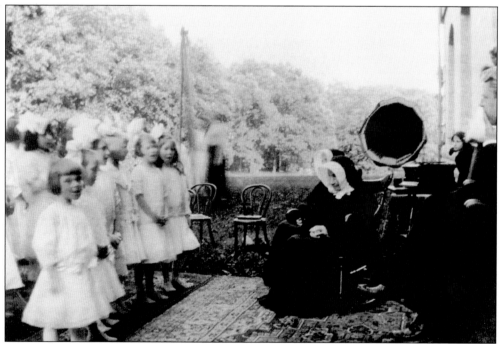

Mother Mary Xavier, leader of the Sisters of Charity and founder of both the Academy and the College of St. Elizabeth, enjoyed listening to a group of academy students sing along with her gramophone *c.* 1915.

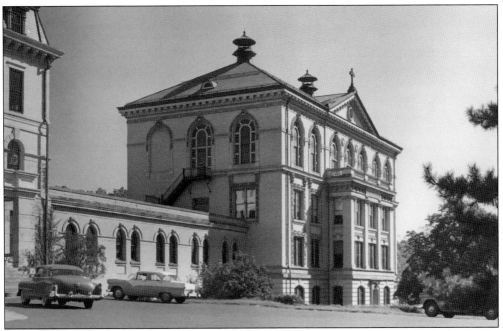

Xavier Hall, the four-story building on the right, opened in 1901 as the first building for the College of St. Elizabeth. The building was and is in the large complex of structures on the front part of the campus. It is now the main building of the Academy of St. Elizabeth.

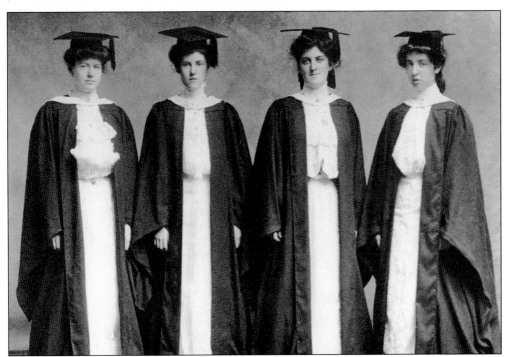

New Jersey history was made on June 18, 1903, when these four St. Elizabeth's students received the first four-year degrees from a New Jersey women's college. They were, from left to right, Mary Ennis, Esther Kenna, Seton McCabe, and Blanche Maskell.

When Mother Mary Xavier Mehegan died on June 24, 1915, her life and teachings had touched so many persons in all walks of life that the somber occasion became a soaring farewell tribute. Coming to Morris County in 1859 as head of the Sisters of Charity of New Jersey, she built

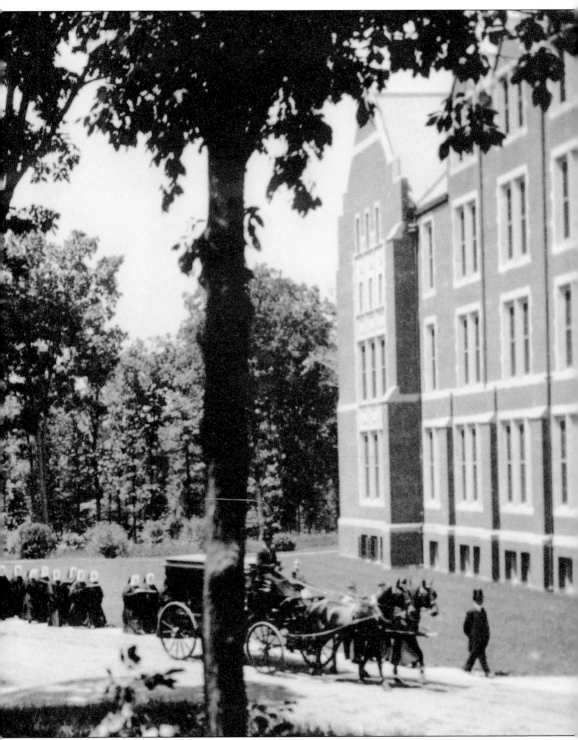

up a property exceeding 400 acres. She established first the Academy and then the College of St. Elizabeth. Equally she built the Sisters of Charity into 1,200 sisters and started 94 missions. Santa Maria Hall, built in 1913 for the college, is on the right.

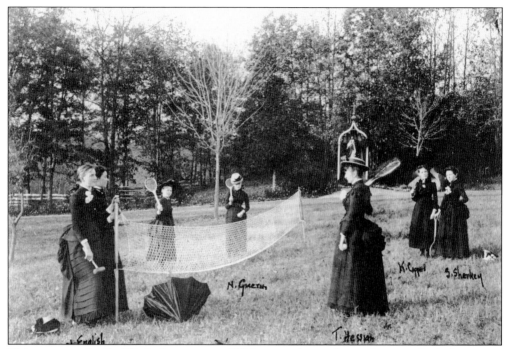

This game on the St. Elizabeth campus *c.* 1886 seems obscure by modern standards, but it was lawn tennis played in ankle-high grass. Bustles, long skirts, and straw hats were favored. Four of the players were casually ready; the rest seemed to have minimal interest.

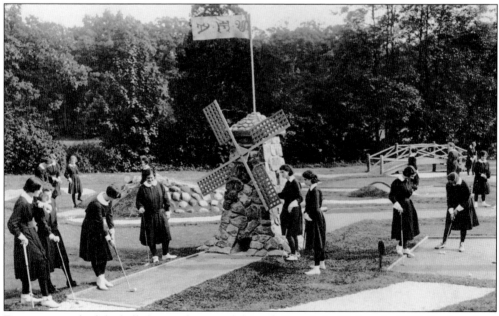

Everyone watched the ball about to be putted through the windmill's base in 1930. Student dress had changed radically since the tennis game. These are Academy students, but the miniature golf course undoubtedly was also used by college women.

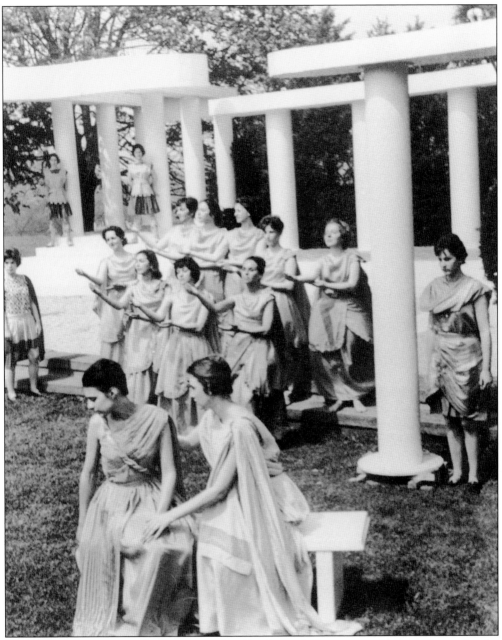

Greek productions every four years in the Greek amphitheater provide a major outlet for St. Elizabeth College students who love the classics. This scene is from *Antigone*, performed in the 1930s. The amphitheater is also used for other activities, such as commencement.

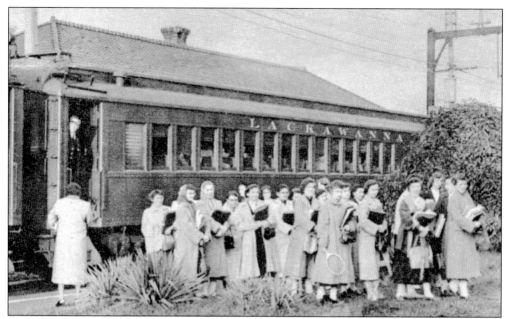

In 1955, when the photograph of students leaving a Lackawanna Railroad coach was taken, many of the students were railroad commuters. That has changed; now, nearly all students live on campus or commute by automobile.

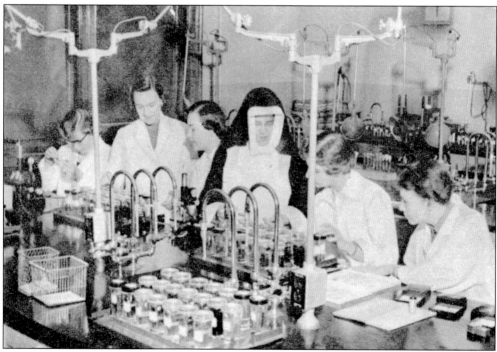

The chemistry laboratory scene was taken in 1955 for a *Newark Sunday News Magazine* article. The laboratory was extensive and modern for the period. Science is an important part of the college curriculum.

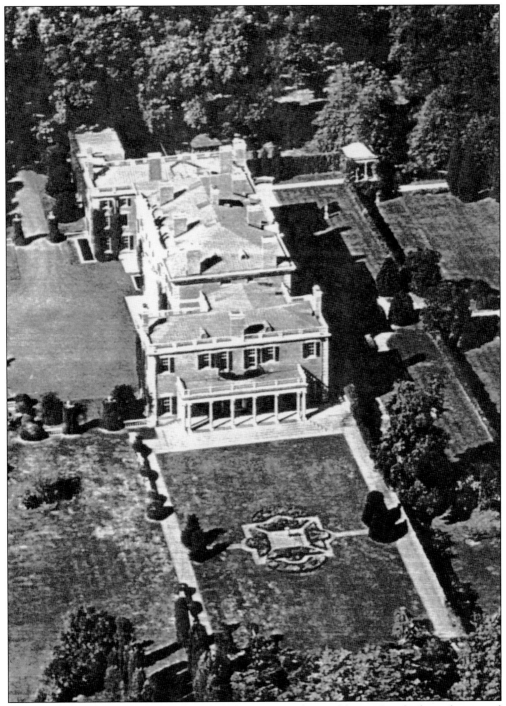

Fairleigh Dickinson University likely has the most opulent "old main" in higher educational history. This 100-room mansion purchased in 1955 has been carefully adapted to meet today's needs. Care is taken to preserve the building's historical and architectural integrity. In 1955, when this aerial view was photographed, the building was used for many academic and administrative programs that are now conducted in new buildings on the campus.

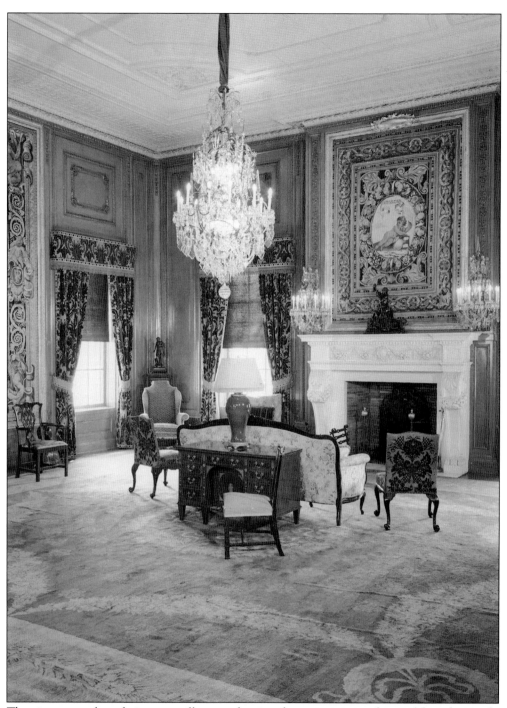

The pictures on these facing pages illustrate the size of mansion rooms, the regal furnishings of a century ago, and the adaptation to modern needs. This is the drawing room as it appeared in its heyday, replete with furniture, a crystal chandelier, and wall hangings, which if available today, could sweeten a university budget.

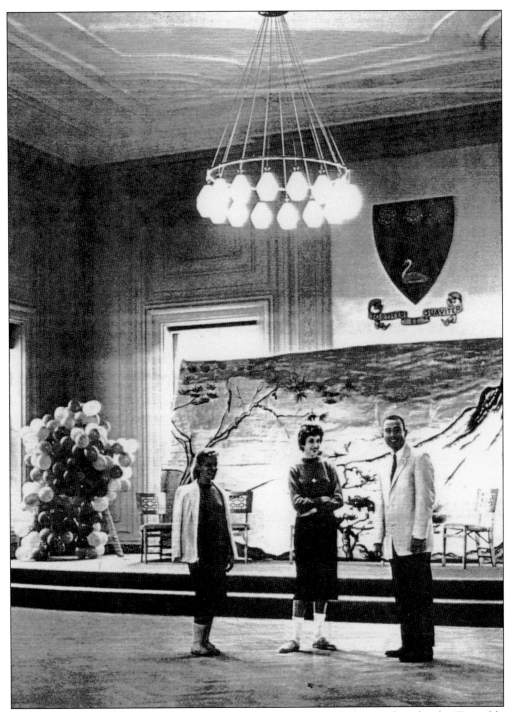

This is how the drawing room looked shortly after Fairleigh Dickinson bought the Twombly estate and transformed buildings into a fine university setting. The tapestries, rugs, and other furnishings all were sold at auction before the university moved in. The room, featuring a workaday chandelier and a long stage, can hold more than 300 people for a major affair.

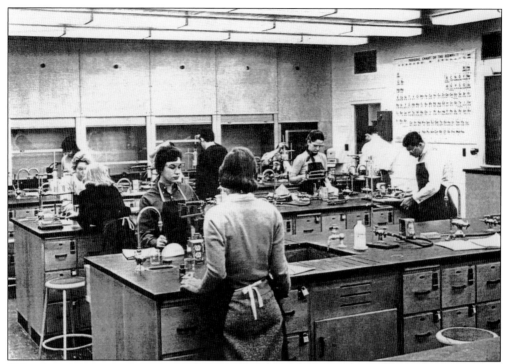

Other large rooms were put to good use, a good example being the 1955 laboratory, pictured above, that was quickly equipped to train budding scientists. The mansion's long, bright and rich-looking hall, below, provided an impressive welcome to Fairleigh Dickinson University.

Six

VILLAGE NO MORE

All of New Jersey—and the nation—faced dramatic change. Encouraged by the GI Bill of Rights, World War II veterans rushed to the country to buy houses erected on former farm acreage. By the 1970s, thousands of newcomers lived in Florham Park home developments. Other thousands each day shopped in the borough's new mini-malls, taught or studied at the borough's two higher education institutions, or worked in the many new light industries. The historic crossroads at Columbia Turnpike and Ridgedale Avenue became a confusing maze of morning and evening rush hour traffic. The old village had almost disappeared.

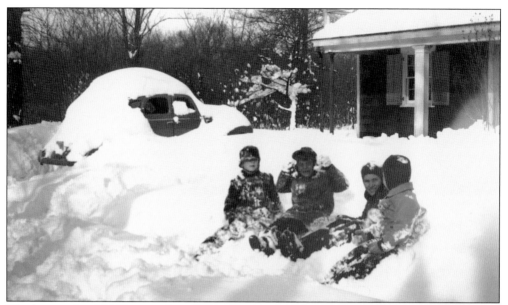

The last week of 1947 opened on December 26 with a record 26 inches of snow. Children frolicked in the drifts outside the Weis home on Park Street. Then a protracted sleet storm on New Year's Eve froze the snow hard and tore down telephone and electric lines.

The combination of sleet and snow plunged much of New Jersey into darkness for nearly two weeks, an unwelcome throwback to past days of candlelight and overcoats.

By spring, the area had returned to business as usual. On Ridgedale Avenue, Lanning's store on the left had become two business establishments, including a small eating place. Bucky Slate's gas station was just beyond, and in the distance was the home of one-time teacher Geneva Pruden.

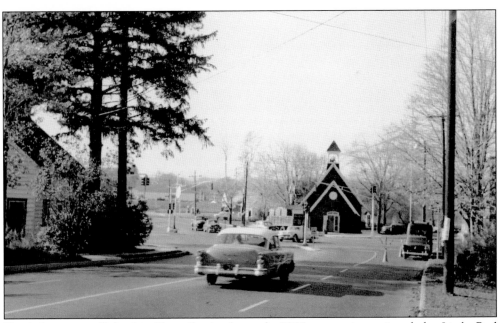

Headed west on Columbia Turnpike in the early 1960s, motorists enjoyed the Little Red Schoolhouse. Yet, as widening of the turnpike seemed ever on the horizon, the school's future was always in question. The old Clancy house stood on the left under tall pine trees.

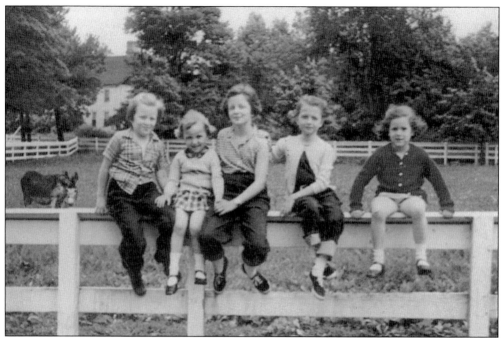

Even these little girls seated on Regalia's pony farm fence on Hanover Road on July 3, 1953, sensed that Florham Park was changing. But it was still a joyous time for the five, who were, from left to right, Jean Martin, Carol Johnson, Betsy Raube, Gloria Johnson, and Sally Raube.

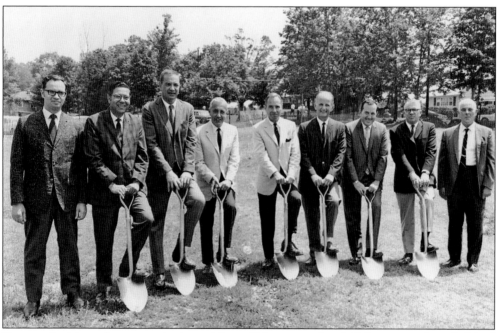

Preservationists and conservationists might well have wondered if the national symbol had become crossed spades on a shield of smiles. Florham Park officials unleashed spades and smiles to hail progress at another development site, this time the new borough hall.

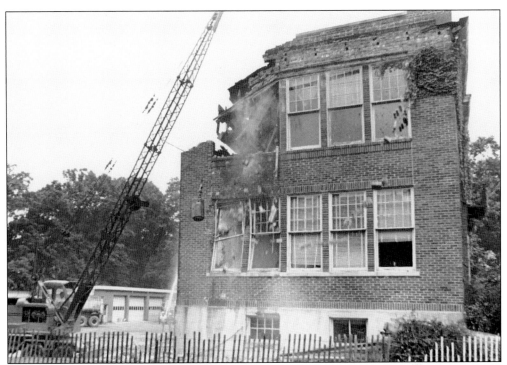

Wrecking balls went to work. The brick walls of the 1914 school on Ridgedale Avenue fell before the pounding ball in 1976. The building had served in many ways after the new Ridgedale School opened in 1934, including as the borough hall and police headquarters.

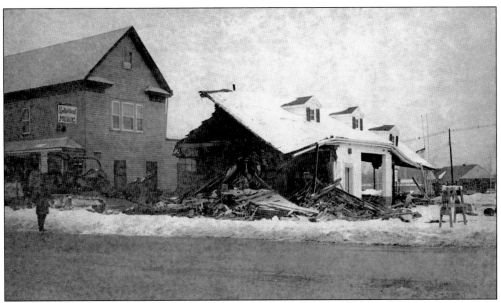

While it was far from being a historic site or scenic landmark, Bucky Slate's Esso station was well known before demolition in 1971. Lanning's store to the left housed music and hardware stores. The shade trees along Ridgedale Avenue had been felled.

The handsome pine trees in front of the Clancy home at the corner of Ridgedale Avenue and Columbia Turnpike became firewood, and the house was leveled. The replacement was a new Esso station across the street from Slate's old place. Also in the scene, the AAA occupied and had added a wing to another old house, and the Afton Restaurant was much enlarged.

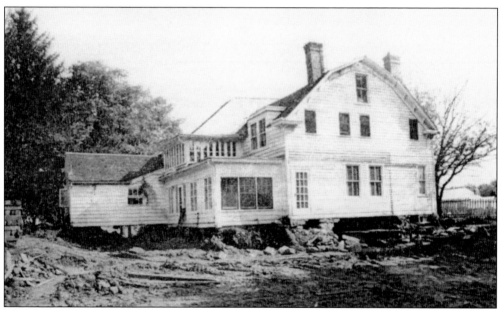

The Ward House, built in 1750, was moved to widen an exit from Columbia Turnpike. Also known as the Conlon House, it was owned by Florham Park Historical Society founder Martha Conlon at the time of the move.

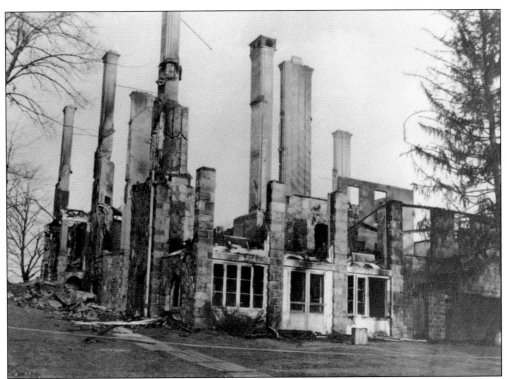

Two ties with Dr. Leslie D. Ward's Brooklake Park estate fell to flames, further reducing the number of local historic sites. After part of the estate became Braidburn Country Club in 1923, Ward's palatial home became the clubhouse. A spectacular fire destroyed the mansion, pictured above, in November 1950, leaving only five chimneys and parts of the wall intact. Another blaze, pictured at right, destroyed the clock tower on the old estate a decade later, in 1960.

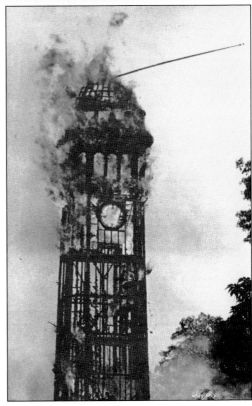

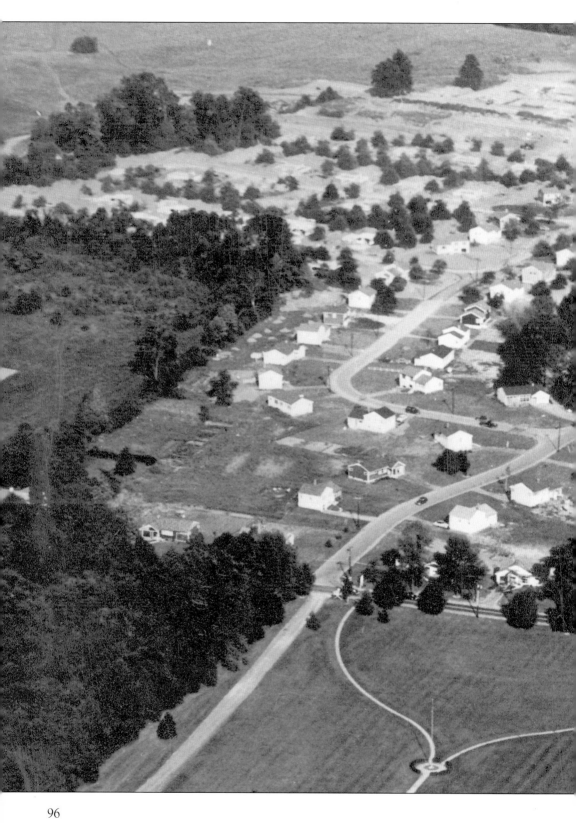

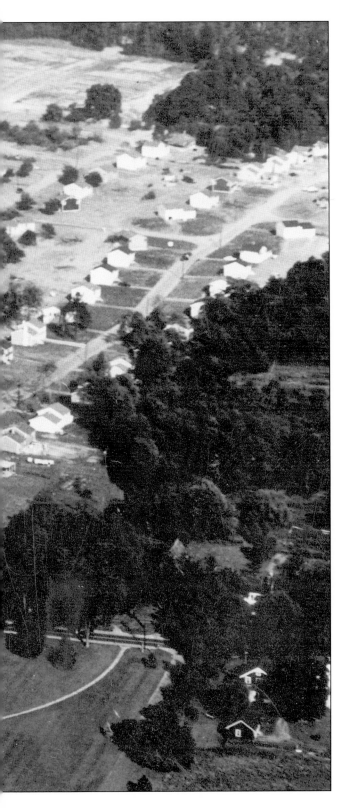

Looking northeastward across the Florham Park School and its broad front lawn in the late autumn of 1951, an aerial photograph caught the beginning of the huge development called Afton Village. A press release for this photograph said 30 houses were "sold and occupied," 63 more were "near completion," and "another 60 would be started soon." Houses cost $15,800 to $17,200. Built in Lloyd Smith's apple orchard, the project left few trees. Afton Village is now a well-shaded, well-maintained part of the community.

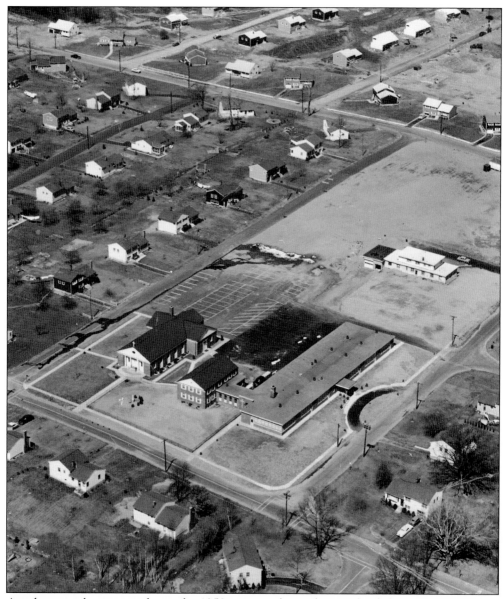

Another aerial view in the early 1950s centered on the newly dedicated Holy Family Church and school, but the photograph's upper part defines further the expanding area of housing development. Tall trees of the present have risen from saplings planted then. The large Holy Family plot was a 4-acre grant from Lloyd Smith. Holy Family's first pastor, Rev. John P. O'Connell, led the church through its subsequent rapid growth.

The first of the Lloyd Smith church grants went to Calvary Presbyterian Church, at right, completed in 1955 on a small knoll beside Ridgedale Avenue. Good Shepherd Lutheran Church, below, became the third major congregation to build. Its young pastor Paul V. Strockbine raised much of the money for this edifice on Ridgedale Avenue near Brooklake Road. It opened for services on April 8, 1962.

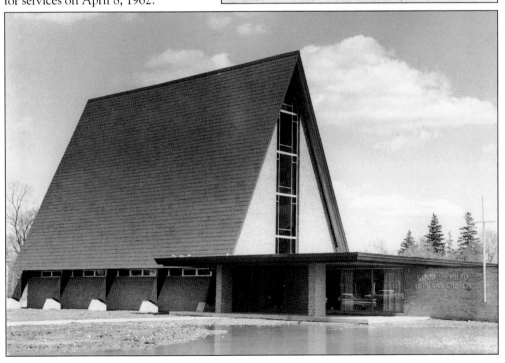

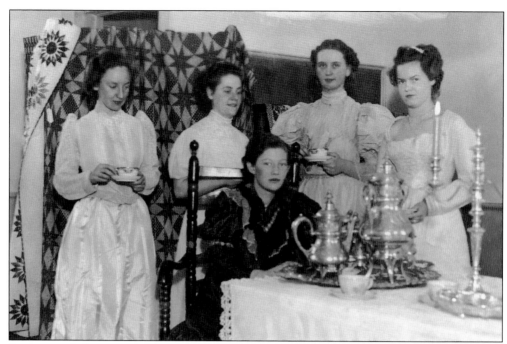

During rapid change, someone must seek to preserve and interpret the past and someone must record the present. The major historical leader was Martha Conlon, shown here seated at a special gathering of Florham Park Historical Society members.

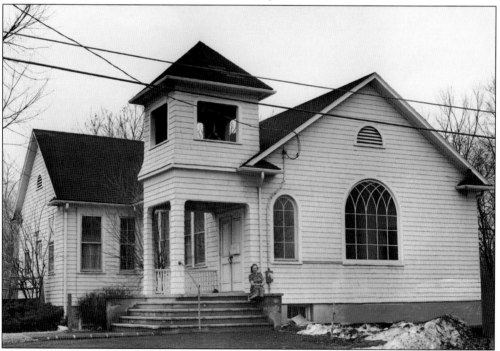

The chief keeper of the present was Lyla Brumbaugh, seen here on the porch, who bought the former Presbyterian church on Columbia Turnpike in 1964. She made it her home and the office of the *Florham Park Community News*, founded in 1959 to depict borough happenings.

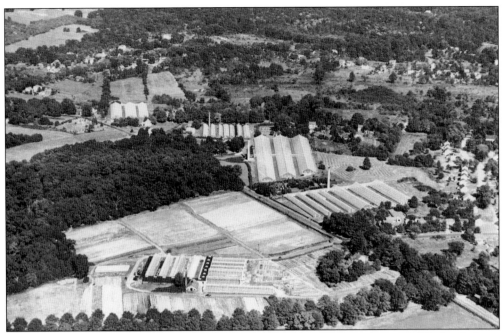

Florham Park's early rose growers were close to the borough center; as late as 1979, the Di Lauri family grew roses near Columbia Turnpike. By 1950, rose growing was centered near the intersection of Ridgedale and Greenwood Avenues, pictured above. Most greenhouses in this photograph were in Florham Park. In 1947, Frank Manker bought the Vert-Totty greenhouses and made them into an impressive complex, shown below. Manker's business closed in 1971.

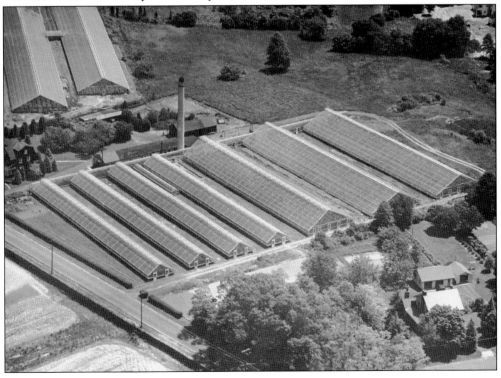

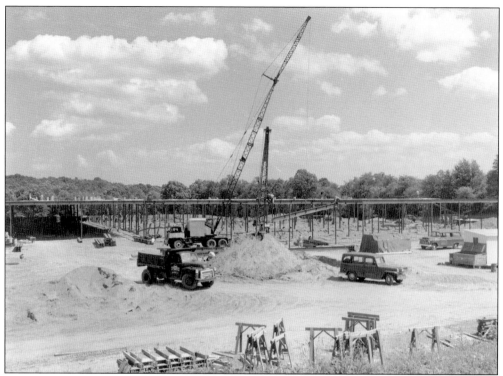

A pressing need for ratables to offset municipal costs led the borough to seek light industry in 1954. The first major company to build was Automatic Switch Company (ASCO) of Orange, whose large project on Hanover Road, shown in two views, covered the pastureland of a former dairy farm. Contractors used modern techniques such as flying air-conditioners in and other materials to on-site locations. By 1985, ASCO employed 1,300 people.

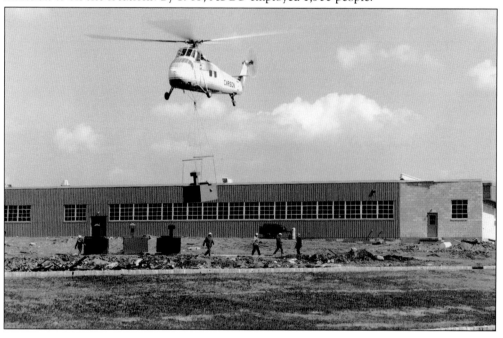

Ohaus Scale Corporation of Union, a leading maker of weights and balances, purchased land on Hanover Road in 1967. Two years later the company moved into this new plant. Its variety of precision scales and weights is the standard for industries, schools, and colleges.

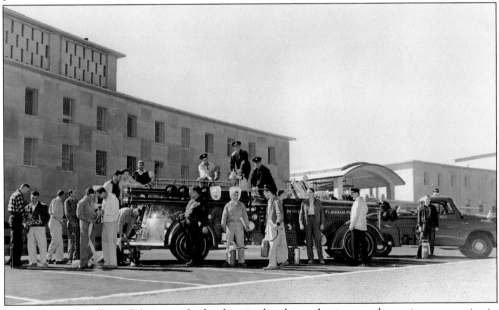

A pleasant side effect of the arrival of industries has been the interest by major companies in local volunteers. As an example, Exxon Research and Engineering Company, which bought a major part of the Twombly estate in 1955 to build a huge research facility, helped the fire department get new equipment. Firemen posed during a drill outside one of the laboratory buildings in the Exxon complex.

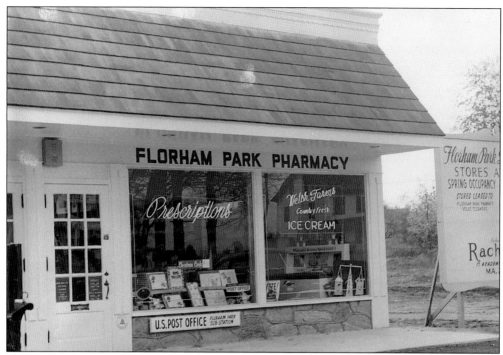

Shopping centers along Ridgedale Avenue brought the first supermarket and the first drugstore. The latter, Florham Park Pharmacy, above, was known to everyone as "Stan Beck's." The personable young pharmacist, below, never refused an after-closing call to his home 5 miles out of town, even at 3 a.m. Stan Beck also volunteered in many activities, including the local rescue squad and the fire department. Note especially the sign on the store: U.S. Post Office. Beck sold only stamps and sent out mail, but it was a start toward a real post office.

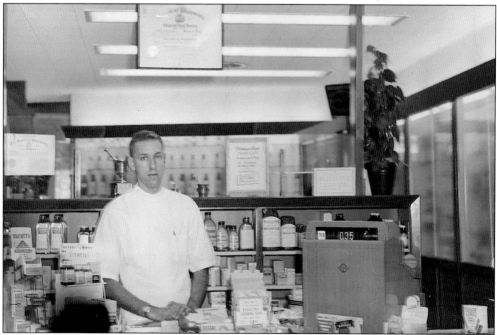

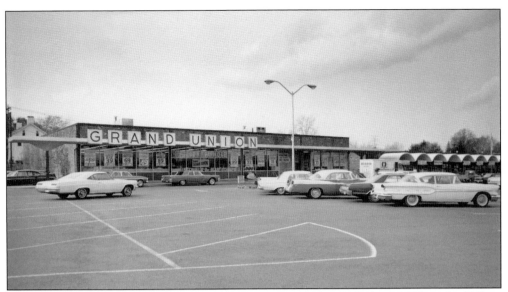

The second and biggest supermarket in town was Grand Union, built in 1960 in the Village Shopping Center, between Ridgedale Avenue and Columbia Turnpike. The center was and is most notable for the post office, which opened there in February 1963.

The new postmaster, James Luciano, campaigned from the time he took the post to get Florham Park named a first-class postal facility. His efforts succeeded in 1971, as new business and industry and a much larger population represented brisk postal business.

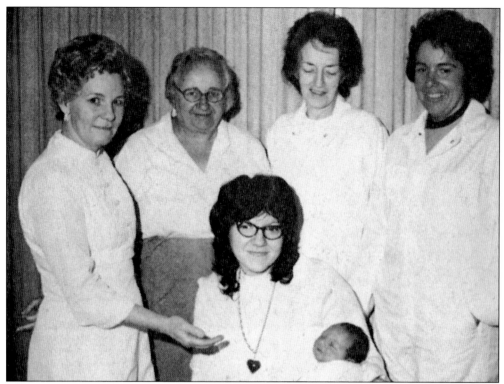

Volunteerism has been a major facet of the borough, and it has had special rewards. The first baby delivered by the Memorial First Aid Rescue Squad arrived on May 16, 1973, 22 years after the squad was founded. Attending mother Louise Parante and son Douglas Scott were, from left to right, Marge Sztuk, Ann Toop, Claire Bundschuh, and Betty Garcia.

Policemen have many professional duties, but they often also become volunteers to help serve community needs. One such contribution is the running of an early bicycle inspection by the Foundation for Safety.

106

Florham Park's Fire Department's volunteer heritage predates by two years the borough's founding in 1899. Thus, there was pleasure at groundbreaking ceremonies for the Brooklake Road firehouse in 1960. Joining Mayor Tom Vultee and Fire Chief Gene Jewell were architects, contractors, and other firemen.

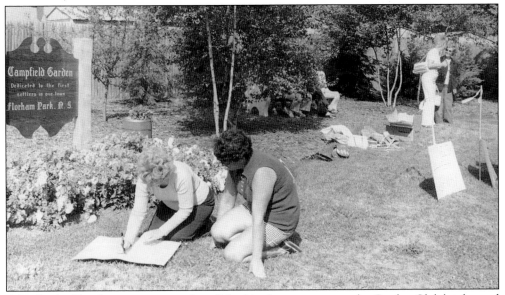

After Bucky Slate's gas station was demolished in the town center, the Garden Club brightened the corner by designing, planting, and maintaining Campfield Garden, dedicated to "the first settlers in our town."

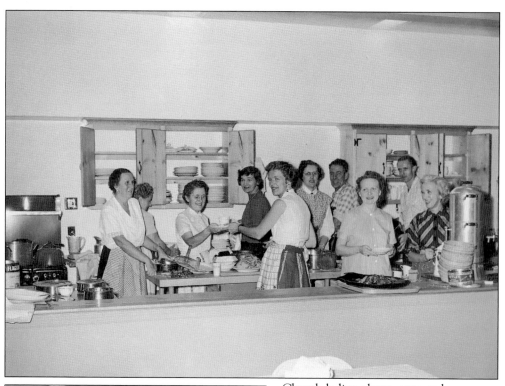

Church ladies, above, prepared many suppers in the 1960s and 1970, often of the ever-popular potluck variety. One of the borough's most popular events for several decades has been the annual firemen's "all you can eat" pancake breakfast, left, cooked and served by firemen.

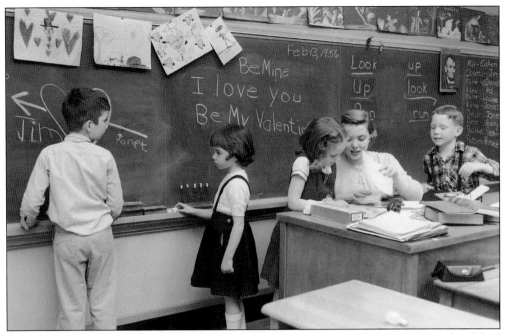

Newcomers entered public schools in such numbers that two new public elementary schools had to be built on a site between Brooklake and Briarwood Roads. First graders and an unidentified teacher exchanged Valentine's Day sentiments in 1956.

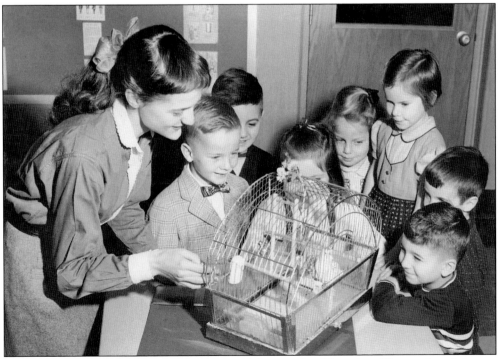

Holy Family School enrollments also increased, but teacher Mary Ann Hermes found time to interest her kindergartners in parakeets. Holy Family is the town's fourth elementary school.

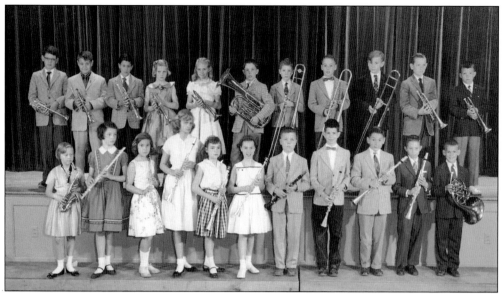

Ridgedale Avenue School, opened in 1934 as the only elementary school at that time, was enlarged, and by the 1960s, it became the middle school for sixth, seventh, and eighth graders. Music, as represented in the 1950s orchestra above, was always a major emphasis at Ridgedale.

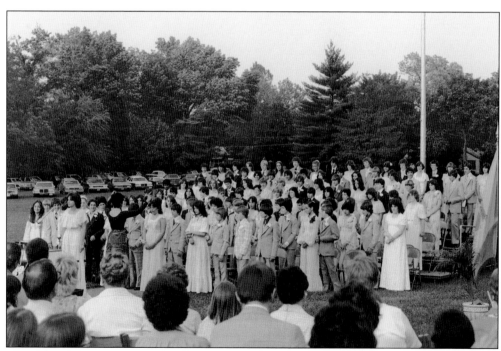

Somewhat astonishing to town old-timers was the increasing size of eighth grade graduating classes after the 1960s. Graduation exercises had to be held outdoors, as with the Class of 1979. After graduation from Ridgedale, students attend regional Hanover Park High School.

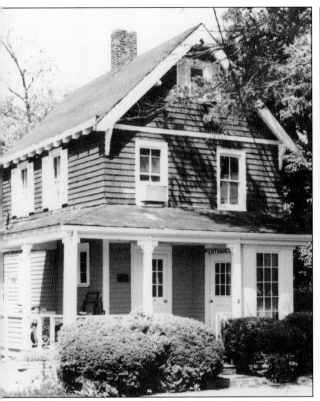 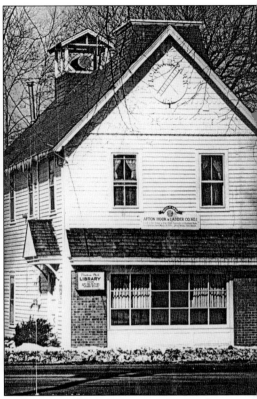

A good library was a major borough need. The first inadequate stab at service was an aged house, above on the left, on Columbia Turnpike in 1965. Somewhat better was the facility of 1968 in the old former firehouse, above on the right. Proper service did not come until a new library was erected in 1980 on a wooded tract near the borough's government area, the playing fields, and the borough swimming pool. The photograph below shows the new library during construction.

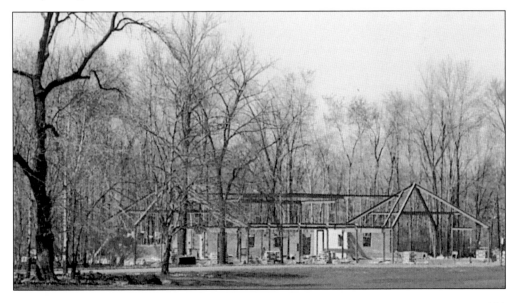

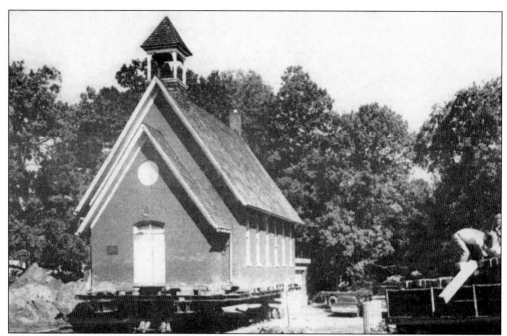

Florham Park residents preserved the prime symbol of their heritage in the 1970s when they overwhelmingly opposed a town plan to move the Little Red Schoolhouse to a site nearly a half mile away. Residents compromised by letting the building be moved back from Columbia Turnpike but on the same site. The relocation took place in 1978.

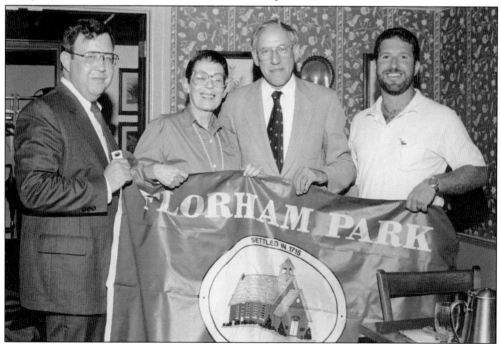

The historic school appeared on the borough flag designed by Pat Longley, noted local artist. She and Stan Beck, center, presented the first borough flag to Frank Sweetin, left, and Dr. John Marelli, right, at a meeting of the Rotary Club.

Seven

BOROUGH AT EASE

Even fire hydrants were part of the fun in 1976 when Florham Park joined the rest of the nation in celebrating the bicentennial of the Declaration of Independence. The borough has always welcomed chances to celebrate; commemorations and parades are regular items on local calendars. The Fourth of July parade, planned and financed completely by volunteers for a half century, is among the oldest continuously operating parades in New Jersey. The Florham Players have been charming local audiences since 1950. Such things as PTA festivals, sports for boys and girls, and other youth activities are an essential part of the fabric of Florham Park life.

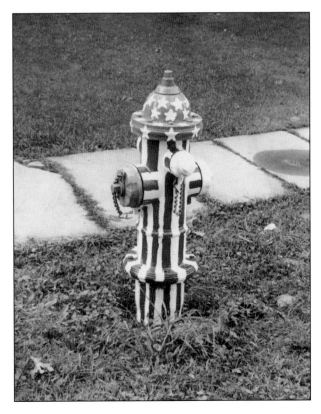

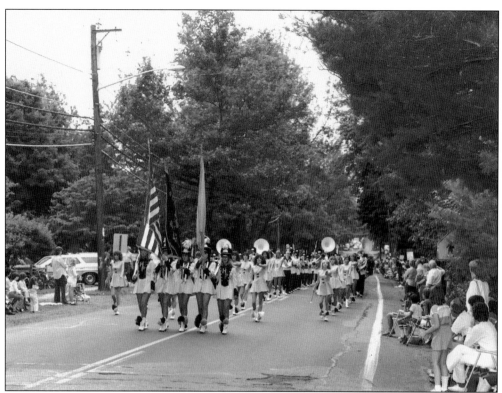

Although now seldom seen as formally attired, as in this case on a steamy July day, the band of the regional Hanover Park High School leads the annual Fourth of July parade through the borough's main streets.

Near the head of the parade are the king and queen, chosen by the PTA. Spectators set their beach or deck chairs along the line of march, seeking the shade of tall trees, and then relax as the floats and marching bands pass by.

114

Music is everything, from start to finish. Certain to be in the parade is the flamboyant mummer's band from nearby Denville. The New Orleans–style string band vies for top popularity with several groups of kilted bagpipe bands.

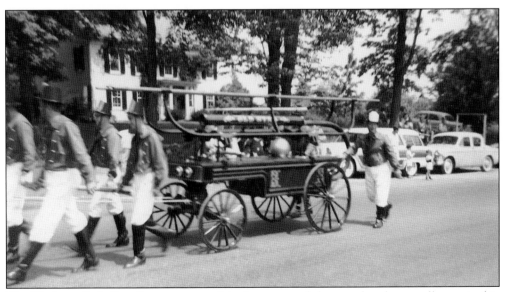

The Florham Park Fire Department, original sponsor of the parade, always rolls out its big modern equipment. However, in the year shown here, the firemen also dressed in old-fashioned uniforms and added their historic hose truck.

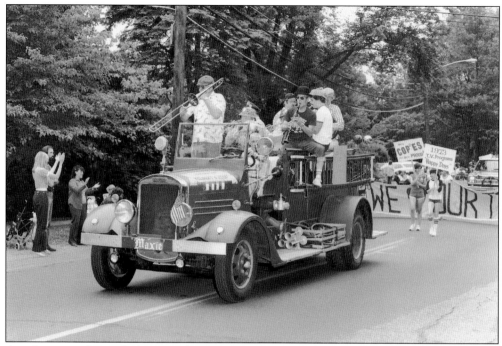

Another annual crowd pleaser is the Gutter Band, originally from Dover. Since many of the performers are of advanced age, the band rides in a truck—the better to play music every minute of the parade.

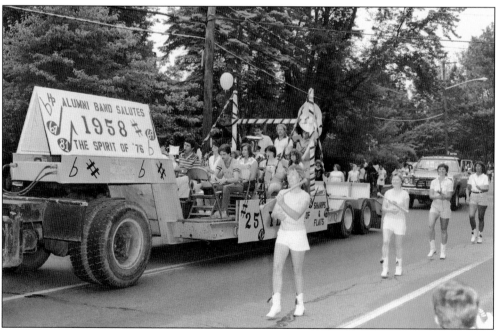

The bicentennial parade prompted members of the Hanover Park High School Class of 1956 to return in the Spirit of '76. These "old-timers," averaging about 38 years of age, also chose to ride on a long trailer, in emulation of the Gutter Band boys.

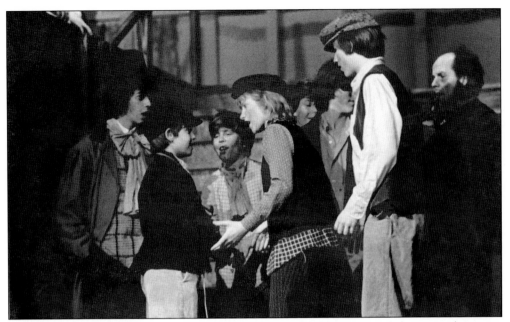

The Florham Park Players entered their 50th year in 1999. Their musicals have run the gamut of popular Broadway shows. One performance each year is turned over to very young players, as in this production of *Oliver* in 1974.

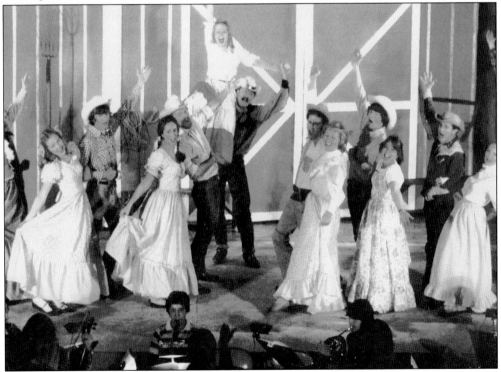

Ever popular *Oklahoma*, first seen in New York during World War II, had a more traditional large cast of young, lusty, singing and dancing adults. The elaborate staging and scenery posed a daunting challenge for the group.

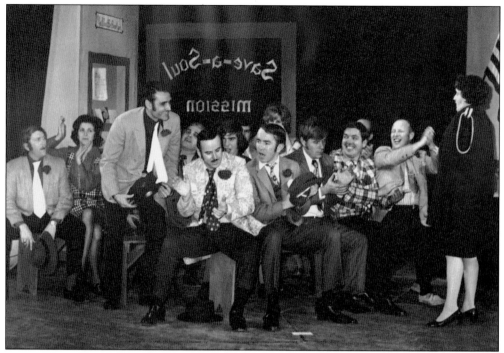

On and on goes the Players' stream of successes, usually staged in the Ridgedale School auditorium. A crowd pleaser always has been *Guys and Dolls*. The rollicking song "Sit Down, You're Rocking the Boat," performed in this scene, is a perennial showstopper.

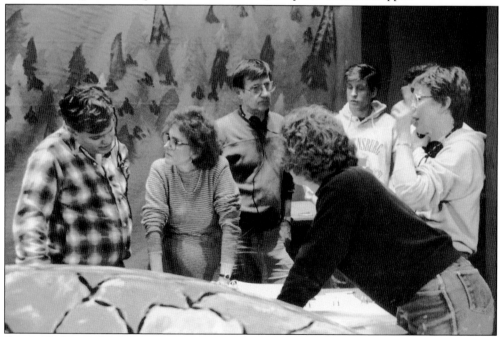

Every Florham Players actor knows success is insured only if behind-the-scenes artists provide stunningly attractive scenery and stagehands quickly and efficiently change settings between scenes.

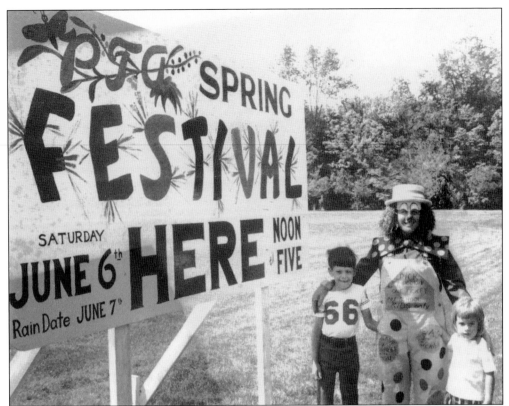

The PTA Spring Festival began on Ridgedale School's huge front lawn during the 1950s and immediately became a fixed annual event for many years. The festival was preceded by colorful publicity, including the sign on the school lawn shown here.

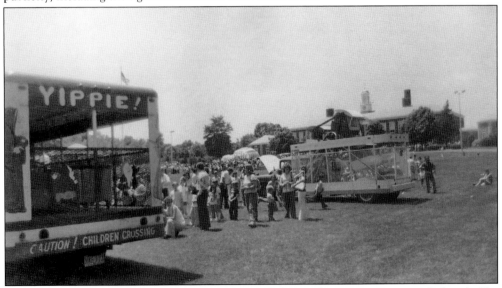

Spread across the wide lawn, the Saturday festivals featured many activities, including kiddie rides, refreshments, and booths to test skills. The festival attracted large crowds and raised funds for the PTA treasury, but it is no longer staged.

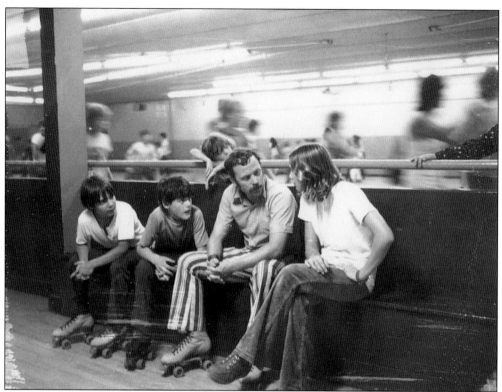

Except for the Little Red Schoolhouse and the Afton Restaurant, no borough institution has had more popularity than the Florham Park Roller-Skating Rink. Opened in 1937, the rink still draws large crowds. Skaters in this 1974 photograph rested between laps.

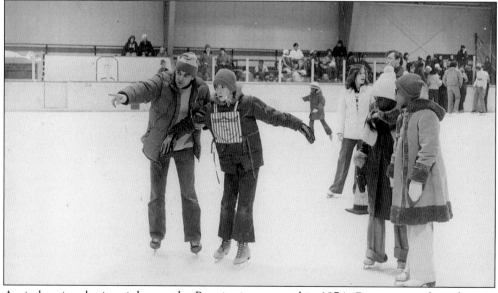

An indoor ice-skating rink near the Passaic river opened in 1974. Customers such as these in this 1977 photograph enjoyed learning and practicing at the rink. However, the rink failed financially, and the building now houses the Living Praise Church.

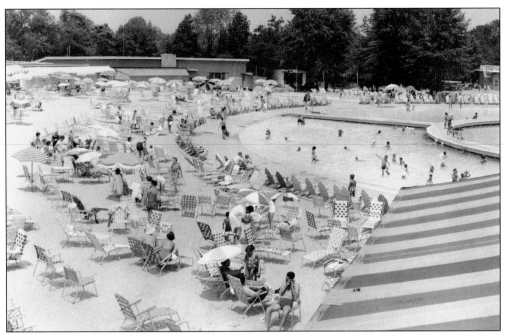

Greenwood Pool, opened in 1953, was on the property where Florham Park Mayor Jesse Keys made boxes 50 years earlier. Although the swimming area was popular, efforts to sell it to the borough failed. Greenwood Pool eventually gave way to another housing development.

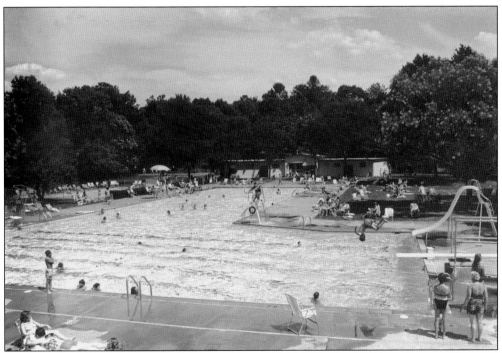

After spurning Greenwood Pool, the town opened its own newly built $275,000 pool in 1964. The pool has proved to be a popular social gathering place, as well as a major summertime source of exercise.

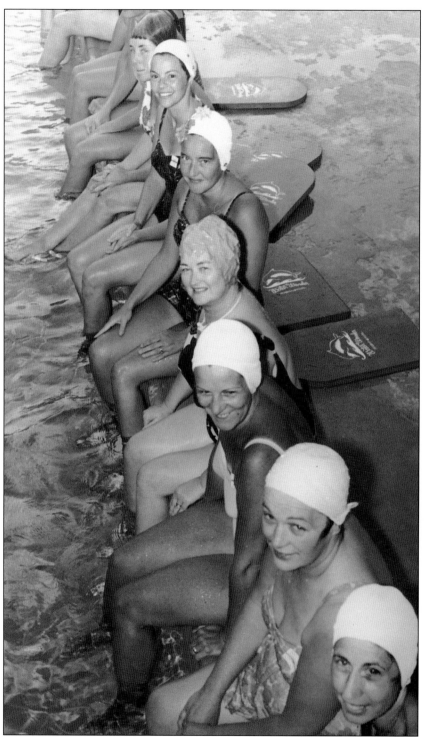

Swimming lessons at the borough swimming pool have been popular for children—but they also attract "swimmer moms" and other young women. When this photograph was taken, bathing caps were very much in style.

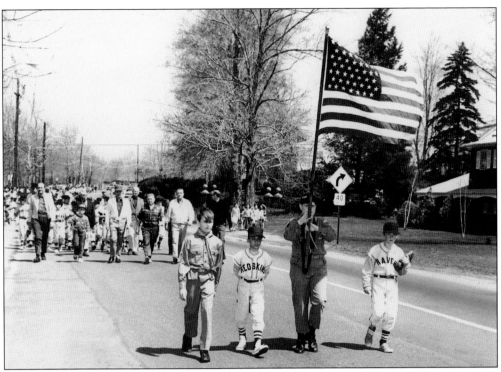

It is almost superfluous in a suburban town to say that the opening of the Little League season is a heralded event. Each April, teams march through town to the league baseball field near borough hall. Fans can spot popular Fred Stobaeus, in the front of the line behind the flag.

Little League games bring out the fans. On the left is borough hall. The white house above the dugout in the background is Boxwood Hall, former home of Lloyd Smith, the millionaire who once owned all this land.

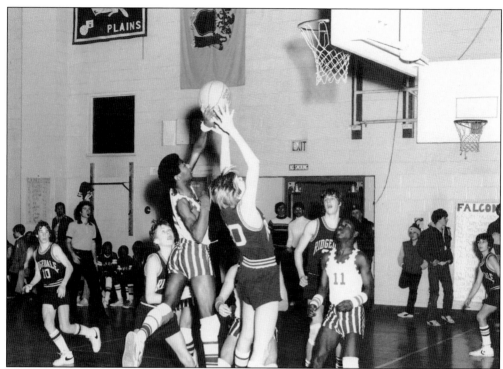

Basketball is a vigorous sport in Ridgedale School and in Hanover Park High School, where borough students compete on a secondary level. A particular rival for Ridgedale is Morristown, shown above in an under-the-basket confrontation with the local five.

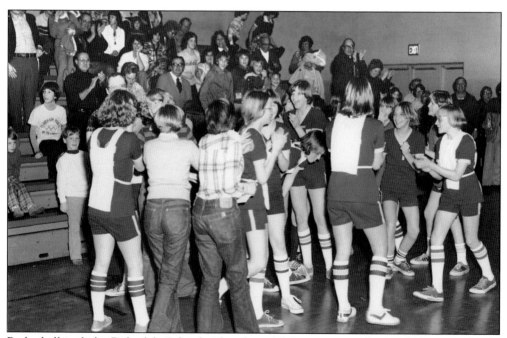

Basketball includes Ridgedale School girls, whose jubilance was evident in 1977 immediately after they had won the prestigious Morris County title.

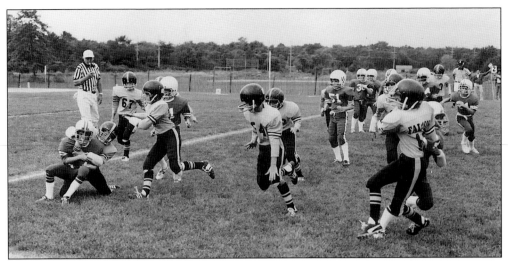

Adult volunteers keep diversified youth sports programs active in all seasons of the year. Football players compete in an intercommunity league every autumn, as in this game against Morris Township in September 1978.

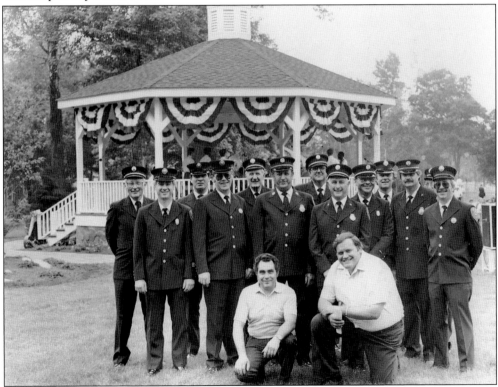

Volunteerism reached a peak in 1982 when volunteer firemen built and donated this gazebo to the borough. Builders were, from left to right, as follows: (front row) Mike Pacifico, electrician, and Lou Nucci, mason; (back row) Ed Tallau, Frank Sabatino, Keith Hillabrant, Bud Tunis, Bud Kirby, Andy Picone, Charles Sedlak, Chet Hermes, Albin Kellogg, Dave Tappen, and Bill Zuckerman. Each summer, ten open-air concerts are presented in the gazebo before crowds that often number in the thousands.

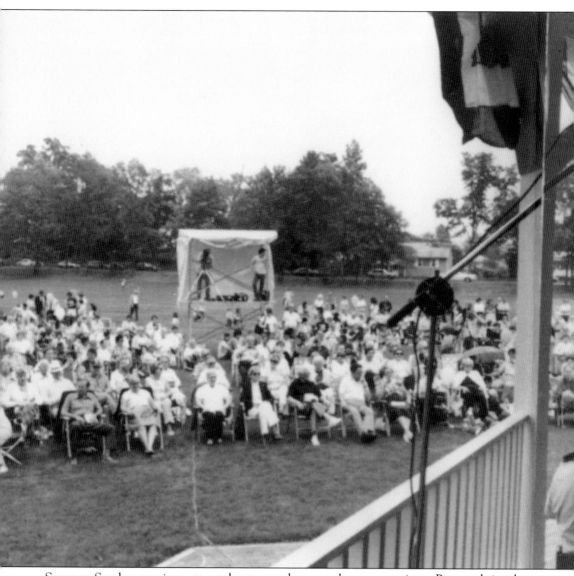

Summer Sunday evenings attract large crowds to gazebo presentations. Patrons bring lawn chairs and whatever refreshments they savor, and then relax and listen as the sun goes down

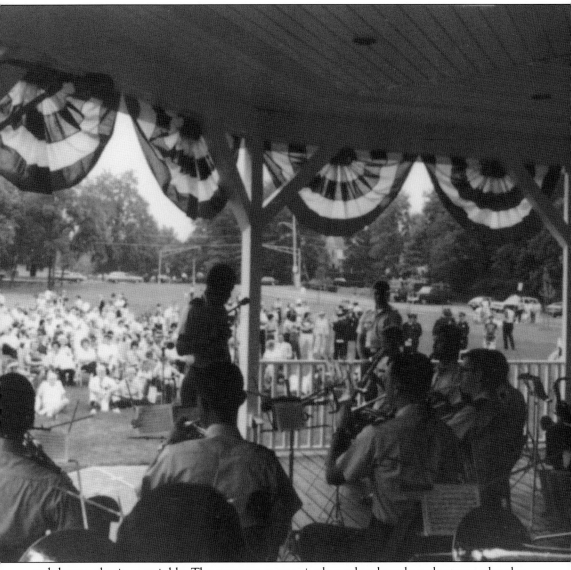

and the stars begin to twinkle. The concert program is planned and run by volunteers, who also conduct an annual fund drive to pay for the visiting musical groups.

Two of Florham Park's most admired citizens, both deceased, were Mayor Joe Crane and Fred "Mr. Recreation" Stobaeus. Crane, mayor when the borough entered the difficult days of expansion in the late 1950s, is remembered for a calm, judicious approach that asked always what was best for his town. Stobaeus, a volunteer, set the direction that Florham Park's recreational program has taken for more than 30 years.